MODERN ART

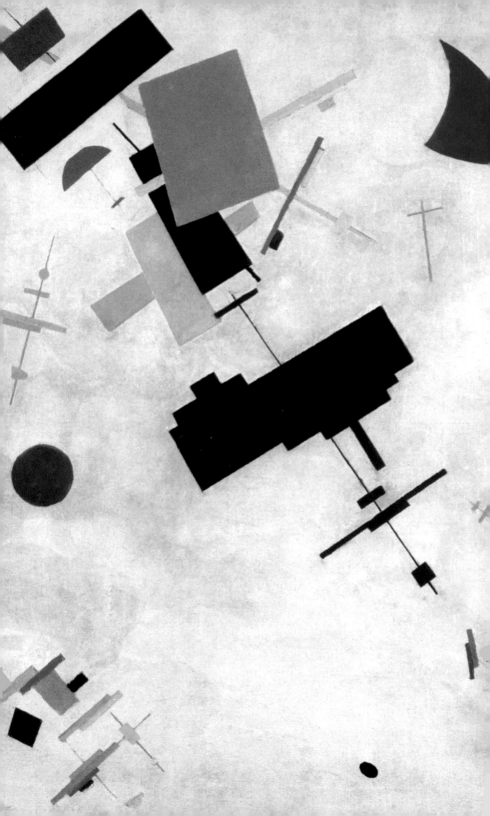

ART ESSENTIALS

MODERN ART

—

AMY
DEMPSEY

—

 Thames & Hudson

CONTENTS

INTRODUCTION

The vocabulary used to describe modern art – from Impressionism to Installation, Symbolism to Super-realism – has developed into a sophisticated, and often daunting, language of its own. Styles, schools and movements are seldom self-contained or simply defined; they are sometimes contradictory, often overlapping, and always complicated. Nevertheless, the concept of styles, schools and movements persists and understanding them remains crucial to any discussion of modern art. Defining them remains the best way of mapping a notoriously complex and, at times, difficult subject. This book is intended as an introduction, a guide to one of the most dynamic and exciting periods of art.

The sixty-eight styles, schools and movements collected
here bring together the most significant developments
in western modern art. Subjects are presented in broadly
chronological order, from Impressionism in the nineteenth
century through to Destination Art in the twenty-first.
Each entry presents a definition and explanation, an
image of a seminal work and lists of key artists, key
features of the style and collections where you can find
the work. There is also a reference section with a glossary
of modern art terms and an index of artists. The aim is to
provide readers with a way into the wonderful world of
modern art and to equip them with the tools to seek their
own conclusions.

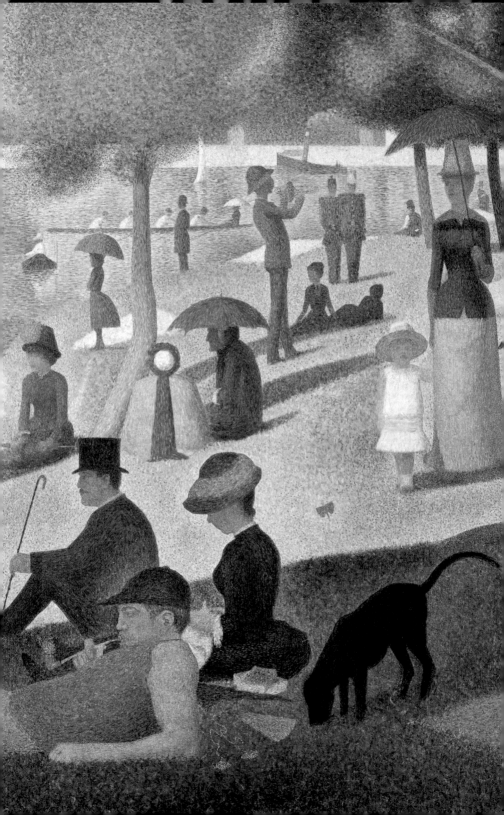

RISE OF
THE AVANT-GARDES
1860–1900

-

**We stand at the threshold of an altogether new art,
an art with forms which mean or represent nothing,
recall nothing, yet which can stimulate our souls**

-

August Endell

1898

IMPRESSIONISM
1860s–c.1900

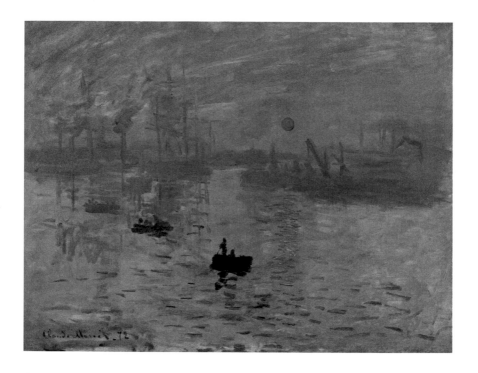

Impressionism was born in 1874 when a group of young artists in Paris who were frustrated by the continual exclusion of their works from the official Salon joined together to hold their own exhibition. Claude Monet, Pierre-Auguste Renoir and Edgar Degas were among the thirty painters who exhibited. Their work was greeted with curiosity and confusion by the public and derision from the popular press. Monet's painting *Impression, Sunrise* (c.1872) provided a mocking critic with a name for the group that stuck: 'Impressionists'.

The Impressionists were self-consciously modern in embracing new techniques, theories, practices and different sorts of subject matter. Their interest in capturing the visual impression of a scene – in painting what one sees rather than what one knows – was as revolutionary as their practice of working outdoors (instead of solely

in the studio) to observe the play of light on objects and light's effect on colour. They sought to capture the fleeting moments of modern life, making a definitive break with accepted subject matter and practice. The sketch-like quality and apparent lack of finish of their work, which many early critics found so objectionable, were exactly the traits that more sympathetic critics soon identified as their strength.

For many, Monet is the 'Impressionist par excellence'; his renderings of Saint-Lazare railway station of 1877, which combine and contrast the modern architecture of the station with the new, amorphous modernist atmosphere (of steam), have been called the most 'typical' Impressionist paintings. Monet's interest in atmosphere would become more prominent in his later series in which he portrayed the same subject at different times of the day, year and weather conditions, such as *Haystacks* (1890–92) and *Poplars* (1890–92).

Renoir's greatest contribution to Impressionism was to apply Impressionist treatment of light, colour and movement to subjects such as the crowd in *Dance at the Moulin de la Galette* (1876). Declaring that painting 'should be something pleasant, cheerful and pretty, yes pretty!' Renoir returned again and again to scenes of Parisians at play, delighting in delicate, colourful representations of sumptuous materials and flesh.

Degas employed the Impressionist practice of using light to convey a sense of volume and movement in his work. Like his colleagues, Degas would sketch in front of a scene, but preferred to continue work in the studio. He went to cafés, theatres, circuses,

Opposite: Claude Monet
Impression, Sunrise, c.1872
Oil on canvas, 49.5 x
65 cm (19½ x 25½ in.)
Musée Marmottan
Monet, Paris

Years later, Monet recounted the story of the naming of the picture and the fuss that ensued: 'They wanted to know its title for the catalogue; [because] it couldn't really pass for a view of Le Havre, I replied, "Use Impression." Someone derived "Impressionism" from it and that's when the fun began.'

Pierre-Auguste Renoir
Dance at Le Moulin de la Galette, 1876
Oil on canvas, 131 x
175 cm (31 x 44¾ in.)
Musée d'Orsay, Paris

Although Renoir painted landscapes with Monet in the late 1860s, his primary interest was always the human figure. His dazzling depiction of the joyful atmosphere of the popular dance garden in Montmartre made this painting one of the masterpieces of early Impressionism.

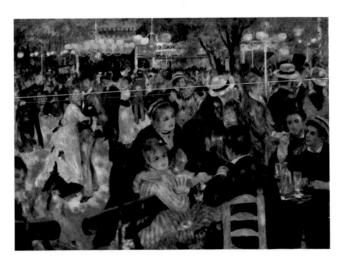

racetracks and the ballet in search of his subject matter. Of all
the Impressionists, the impact of photography is most evident
in his work – with its sense of capturing a fleeting moment, the
fragmentation of bodies and space, and the cropping of the image.

By the late 1880s and 1890s Impressionism was accepted as
a valid artistic style and spread throughout Europe and the USA.
The impact of Impressionism and the Impressionists cannot be
overestimated. Impressionism represents the beginning of the
twentieth century's exploration of the expressive properties
of colour, light, line and form. Perhaps most important of all,
Impressionism can be seen as the start of the struggle to free
painting and sculpture from its solely descriptive duty in order
to create a new language and role akin to other art forms, such
as music and poetry.

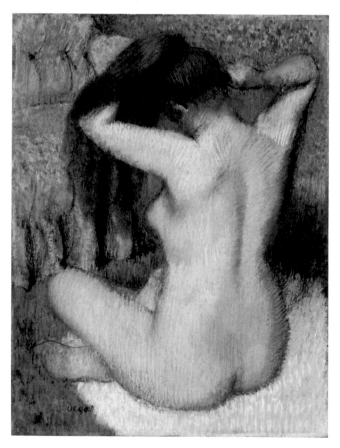

Edgar Degas
*Woman Combing her
Hair*, c.1888–90
Pastel, 61.3 x 46 cm
(24⅛ x 18⅛ in.)
Metropolitan Museum
of Art, New York

**In the late 1880s Degas
began to use pastels and
a 'keyhole aesthetic'
to portray women in
natural, intimate poses
unprecedented in the
history of art.**

Mary Cassatt
*Little Girl in a Blue
Armchair*, 1878
Oil on canvas,
89.5 x 129.8 cm
(35¼ x 51⅛ in.)
National Gallery of Art,
Washington, DC

Cassatt's work seems to
draw on many sources
– the love of line seen
in Japanese prints, the
bright colours of the
Impressionists and the
skewed perspectives and
photographic cropping
of Degas – to create a
unique style capable of
rendering her typically
tender, intimate views of
domestic life.

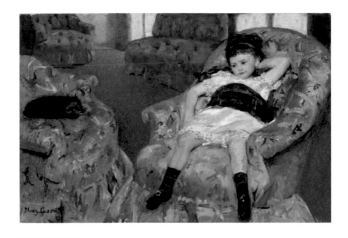

KEY ARTISTS
Mary Cassatt (1845–1926), USA
Edgar Degas (1834–1917), France
Claude Monet (1840–1926), France
Camille Pissarro (1830–1903), France
Pierre-Auguste Renoir (1841–1919), France

KEY FEATURES
Sketch-like quality, apparent lack of finish
Sense of spontaneity, play of light and movement
Fragmentation and disintegration of form by light and shadow
Exploration of ways to capture the visual effects of light and
 weather in paint

MEDIA
Painting and sculpture

KEY COLLECTIONS
Chichu Art Museum, Naoshima, Kagawa, Japan
Courtauld Gallery, London, UK
Metropolitan Museum of Art, New York, NY, USA
Musée Marmottan Monet, Paris, France
Musée de l'Orangerie, Paris, France
Musée d'Orsay, Paris, France
National Gallery, London, UK
National Gallery of Art, Washington, DC, USA
Norton Simon Museum, Pasadena, CA, USA
The State Hermitage Museum, St Petersburg, Russia
Thyssen-Bornemisza Museum, Madrid, Spain

ART NOUVEAU
c.1885–1914

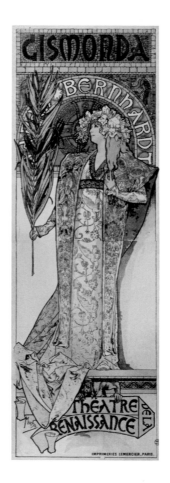

Art Nouveau (French: new art) is the name of the international movement that swept through Europe and the USA from the late 1880s until the First World War. It was a determined and successful attempt to create a thoroughly modern art, typified by an emphasis on line rendered boldly and simply. Two main strains developed: a floral style based on an intricate, asymmetrical, sinuous line (France and Belgium), with the other adopting a more geometric approach (Scotland and Austria).

Though Art Nouveau was an explicitly modern style, it nevertheless drew on past models for inspiration, in particular the overlooked or the exotic, such as Japanese art and decoration, Celtic and Saxon illumination and jewellery, and Gothic architecture. Equally important was the influence of science. The impact of scientific discoveries, especially those of Charles Darwin, meant that the use of natural forms was no longer seen as romantic and escapist, but modern and progressive. Art Nouveau encompassed all the arts but its most successful manifestations were in architecture, graphics and applied arts.

For a time Art Nouveau seemed unstoppable, spreading east to Russia, north to Scandinavia and south into Italy. Its sheer popularity eventually led to its downfall. The market became saturated, taste changed and a new age demanded a new kind of decorative art to express modernity: Art Deco.

Alphonse Mucha
Poster for *Gismonda*,
1894
Colour lithograph, 216 x
74.2 cm (85 x 29¼ in.)
Private collection

One of the most celebrated Art Nouveau graphic artists was Paris-based Czech painter and designer Alphonse Mucha. His posters of sensuous women in luxurious floral settings, such as celebrated actress Sarah Bernhardt, were much loved by the public. The female form was a central motif for many Art Nouveau designers.

KEY ARTISTS AND DESIGNERS
Hector Guimard (1867–1942), France
Victor Horta (1861–1947), Belgium
René Lalique (1860–1945), France
Charles Rennie Mackintosh (1868–1928), UK
Alphonse Mucha (1860–1939), Czechoslovakia
Louis Comfort Tiffany (1848–1933), USA
Henry van de Velde (1863–1957), Belgium

KEY FEATURES
Linear simplicity
Elongated lines and forms
Belief in the expressive properties of form, line and colour
Boldly contrasting colours
Abstracted organic forms and a rhythmic sense of movement

MEDIA
All

KEY COLLECTIONS
Hunterian Art Gallery, Glasgow, UK
Mucha Museum, Prague, Czech Republic
Musée des Arts Décoratifs, Paris, France
Musée de l'École de Nancy, Nancy, France
Victoria and Albert Museum, London, UK
Virginia Museum of Fine Arts, Richmond, VA, USA

SYMBOLISM

1886–c.1910

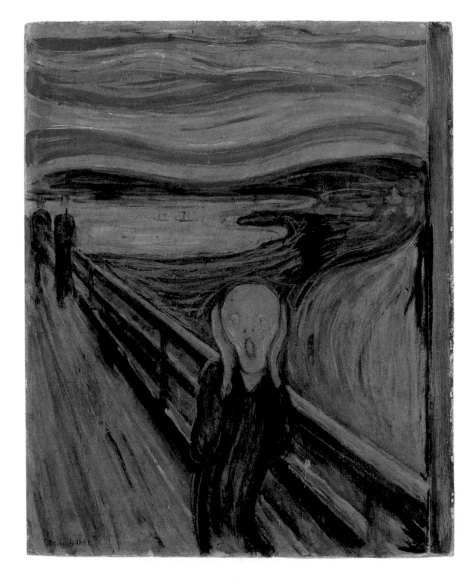

The Symbolists were the first artists to declare that the inner world of mood and emotions, rather than the world of external appearances, is the proper subject of art. Private symbols are used to evoke these moods and emotions. The irrational could, and often was, reached via drugs, dreams, hypnosis, psychoanalysis, spiritualism and occultism. Symbolist work is very diverse, but common themes occur, such as dreams and visions, mystical experiences, the occult, the erotic and the perverse, with the goal of creating a psychological impact.

The Symbolist movement originated in France in 1886, but rapidly became international. French artist Odilon Redon, the painter of dreams, was one of the most characteristic figures, turning the 'torments of the imagination' into art. His works seem to tap directly into the subconscious. Belgian painter James Ensor was another celebrated Symbolist. His characteristic motifs of carnival masks, monstrous figures and skeletons, combined with violent brushwork and gruesome humour, present pictures of the dark side of life. Another foreign painter adopted by the French Symbolists was Norwegian Edvard Munch. His most famous work, *The Scream* (1893), is a graphic visual expression of the psychological states of despair and horror, both internal and external.

Edvard Munch
The Scream, 1893
Tempera and crayon on
cardboard, 91 x 73.5 cm
(35⅞ x 29 in.)
National Gallery, Oslo

**When the painting
was reproduced in
the Parisian magazine
Revue Blanche in 1895,
Munch included the
following text: 'I stopped
and leaned against the
balustrade, almost dead
with fatigue. Above the
blue-black fjord hung
the clouds, red as blood
and tongues of fire. My
friends had left me, and
alone, trembling with
anguish, I became aware
of the vast, infinite cry
of nature.'**

KEY ARTISTS

James Ensor (1860–1949), Belgium
Gustave Moreau (1826–1898), France
Edvard Munch (1863–1944), Norway
Odilon Redon (1840–1916), France
James Abbott McNeill Whistler (1834–1903), USA

KEY FEATURES

Romantic, dreamlike and decorative
Women portrayed as virginal/angelic or sexual/threatening
Motifs of death, disease and sin

MEDIA

Painting and graphics

KEY COLLECTIONS

Ensor Museum, Ostend, Belgium
Munch Museum, Oslo, Norway
Musée National Gustave Moreau, Paris, France
Thyssen-Bornemisza Museum, Madrid, Spain

NEO-IMPRESSIONISM
1886–c.1900

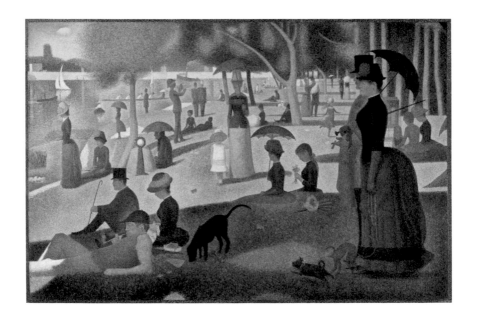

By the early 1880s many Impressionists felt that Impressionism had gone too far in dematerializing the object. This concern was shared by a number of younger artists, including Georges Seurat and Paul Signac. Their style, which sought to retain the luminosity of Impressionism while solidifying the object, was labelled 'Neo-Impressionism' (New Impressionism).

Signac and Seurat were fascinated by scientific colour theories and optics and worked together to develop a technique called 'divisionism', or 'pointillism'. Beginning with the premise that colour is mixed in the eye instead of on the palette, they perfected a method for applying dots of pure colour on the canvas in such a way that they blend when viewed at an appropriate distance. The divisionist technique produces extraordinary optical effects. Since the eye is constantly moving, the dots never completely meld together, but produce a shimmering, hazy effect like that experienced in bright sunlight. The after-effect is such that the image seems to float in time and space. This illusion is often heightened by another of Seurat's innovations: a pointillist border painted on the canvas itself, sometimes extended to include the frame. The first of a new breed of artist–scientists, Seurat and Signac are part of the genealogy of future movements, such as Kinetic Art and Op Art.

Georges Seurat
A Sunday on La Grande Jatte - 1884, 1884–6
Oil on canvas, 207.5 × 308 cm (81¾ × 121¼ in.)
Art Institute of Chicago, Chicago

Seurat's seminal, monumental canvas is a combination of familiar Impressionist subjects – landscape and contemporary Parisians at play – but it captures not so much the fleeting moment of Impressionism as a feeling of eternity.

KEY ARTISTS

Camille Pissarro (1830–1903), France
Lucien Pissarro (1863–1944), France
Georges Seurat (1859–91), France
Paul Signac (1863–1935), France

KEY FEATURES

Carefully organized
All-over composition
Interest in colour theory and optics
Small dots or short brushstrokes of pure pigment

MEDIA

Painting

KEY COLLECTIONS

Art Institute of Chicago, Chicago, IL, USA
National Gallery, London, UK
Musée de Petit Palais, Geneva, Switzerland
Cleveland Museum of Art, Cleveland, OH, USA

SYNTHETISM
c.1888–c.1900

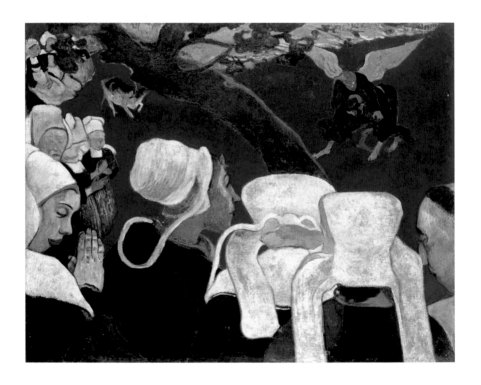

Paul Gauguin, Émile Schuffenecker, Émile Bernard and their circle in France coined the term 'Synthetism' (from *synthétiser*: to synthesize) to describe their work of the late 1880s and early 1890s. Their pictures synthesized a number of different elements: the appearance of nature, the artist's 'dream' before it and deliberately exaggerated forms and colours. The result was a radical, expressive style.

Gauguin, the leader of the group, aimed to paint less what the eye *saw* and more of what the artist *felt*, and created an art in which colour and line are used for dramatic, emotional and expressive effects. His early key work, *The Vision of the Sermon: Jacob Wrestling with the Angel* (1888), reads like a visual manifesto of his revolutionary ideas. The painting of the Breton peasants' vision, with its arbitrary colours and sinuous line, signals a complete break with the optical naturalism of Impressionism. In rejecting the artist's fidelity to the represented world, Gauguin helped pave the way for the abandonment of representation altogether.

Paul Gauguin
Vision of the Sermon: Jacob Wrestling with the Angel, 1888
Oil on canvas, 74.4 × 93 cm (28¾ × 36⅔ in.)
National Gallery of Scotland, Edinburgh

Gauguin asserted that colour and line can be expressive in themselves, and that they can be used to convey intangible ideas and not just objects in the natural world. Here, the inner world of the vision and the outer world of the Breton peasants, divided by the tree branch, are uncompromisingly – and mysteriously – united by the red ground.

KEY ARTISTS

Émile Bernard (1868–1941), France
Paul Gauguin (1848–1903), France
Émile Schuffenecker (1851–1934), France

KEY FEATURES

Simplified forms
Bold colour and line
Exaggerated colours and shapes
Flatness

MEDIA

Painting

KEY COLLECTIONS

Art Institute of Chicago, Chicago, IL, USA
Metropolitan Museum of Art, New York, NY, USA
Museum of Fine Arts, Boston, MA, USA
National Gallery of Scotland, Edinburgh, UK
Pushkin Museum of Fine Arts, Moscow, Russia
The State Hermitage Museum, St Petersburg, Russia
Tate, London, UK

POST-IMPRESSIONISM
c.1895–1910

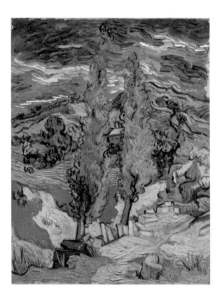

'Post-Impressionism' is the term invented by English critic Roger Fry to cover art that he saw as either coming out of Impressionism or reacting against it. The term encompasses artists not otherwise easily categorized, such as Paul Cézanne, Vincent van Gogh and Henri de Toulouse-Lautrec.

Cézanne's interest was not in the ephemeral qualities of light and the fleeting moment, but in the structure of nature. He painted several viewpoints at once and used small brushstrokes and geometric shapes to analyse and construct nature into a parallel world of art. Van Gogh also studied nature intensely. His mature style is characterized by the use of vibrant colour savoured for its symbolic and expressive possibilities. Toulouse-Lautrec is best known for paintings and prints of Parisian nightlife rendered in his distinctive style of curvilinear lines, bold silhouettes and colours.

The Post-Impressionist artists worked in a broad range of styles and held differing ideas about the role of art. However, they were all revolutionaries who sought to create an art that was other than descriptive realism – an art of ideas and emotions.

Vincent van Gogh
The Poplars at Saint-Rémy, 1889
Oil on canvas, 61.6 x 45.7 cm (24¼ x 18 in.)
Cleveland Museum of Art, Cleveland

In 1889 a quarrel with Paul Gauguin provoked a fit of despair in which Van Gogh severed his left ear. In May of that year he entered the asylum at St Rémy in southern France. He painted this autumnal landscape while there. His mature works' self-expressive quality makes them records of his life and emotions – almost self-portraits.

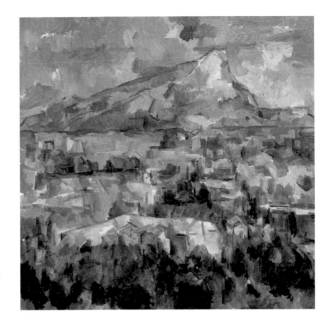

Paul Cézanne
Mont Sainte-Victoire,
1902–4
Oil on canvas, 73 x
92 cm (28¾ x 36⅛ in.)
Philadelphia Museum of
Art, Philadelphia

**After 1877 Cézanne
rarely left Provence,
preferring to work in
isolation, painstakingly
developing an art
that combined
classical structure
with contemporary
naturalism, an art that
he believed would appeal
to the mind as well as
the eye.**

KEY ARTISTS
Paul Cézanne (1839–1906), France
Maurice Prendergast (1859–1924), USA
Henri Rousseau (1844–1910), France
Henri de Toulouse-Lautrec (1864–1901), France
Vincent van Gogh (1853–1890), Netherlands

KEY FEATURES
Expressive use of colour, line and form
Multiple perspectives

MEDIA
Painting and graphics

KEY COLLECTIONS
Cleveland Museum of Art, Cleveland, OH, USA
Courtauld Gallery, London, UK
Kröller-Müller Museum, Otterlo, Netherlands
Musée d'Orsay, Paris, France
Musée Toulouse-Lautrec, Albi, France
Museum of Modern Art, New York, NY, USA
National Gallery of Art, Washington, DC, USA
Philadelphia Museum of Art, Philadelphia, PA, USA
The State Hermitage Museum, St Petersburg, Russia
Thyssen-Bornemisza Museum, Madrid, Spain
Van Gogh Museum, Amsterdam, Netherlands

VIENNA SECESSION
1897–1938, 1945–

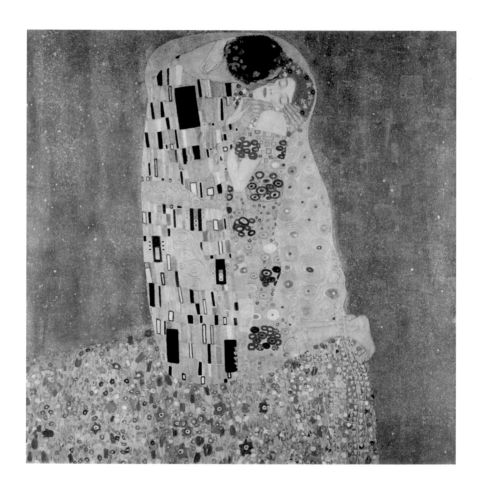

The secession, or breaking away, of young artists from official academies was a feature of the arts in the 1890s, especially in German-speaking countries. The Vienna Secession, formed in 1897, is the most famous. Rejecting the revivalist styles of the conservative academies, they promoted an art that would celebrate modernity and favoured a broader definition of art that included applied arts.

At first the Secessionists were affiliated with Art Nouveau – indeed, in Austria Art Nouveau was called Sezessionstil. From 1900, the work of British applied artists, particularly that of Charles Rennie Mackintosh, became the dominant influence on Sezessionstil. The Austrians favoured his rectilinear designs and muted colours over the more Rococo style of continental Art Nouveau.

In 1905 there was a split in the Secession itself. The Naturalists of the group wanted to focus on fine art. The more radical artists, including Gustav Klimt, wanted to promote the applied arts and left to form a new group, the Klimtgruppe. Klimt's most famous and popular painting, *The Kiss*, is a sensuous, opulent painting of a couple embracing, portrayed in a glittering all-over gold abstract design. The Secession itself continued as a group until 1939, when the growing pressures of Nazism led to its dissolution. After the Second World War, it reformed and has continued to sponsor exhibitions.

Gustav Klimt
The Kiss, 1907–8
Oil on canvas, 180 x 180 cm (70⅞ x 70⅞ in.)
Belvedere Museum, Vienna

Klimt was the co-founder and first president of the Vienna Secession. His distinctive style combines a naturalistic rendering of human skin with exquisite patterning and ornamentation. This celebration of romantic love is one of Klimt's most popular paintings.

KEY ARTISTS AND ARCHITECTS
Josef Hoffmann (1870–1956), Austria
Gustav Klimt (1862–1918), Austria
Koloman Moser (1868–1918), Austria
Joseph Maria Olbrich (1867–1908), Austria

KEY FEATURES
Functionalist approach, geometric compositions
Two-dimensional quality
Decorative

MEDIA
Architecture, applied arts and painting

KEY COLLECTIONS
Association of Visual Artists, Vienna Secession, Vienna, Austria
MAK – Austrian Museum of Applied Arts / Contemporary Art, Vienna, Austria
Neue Galerie New York, New York, NY, USA
Belvedere Museum, Vienna, Austria
Leopold Museum, Vienna, Austria

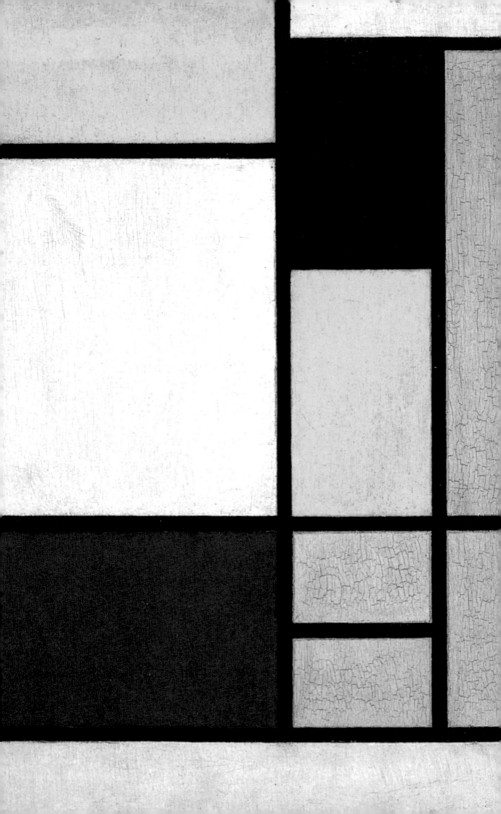

MODERNISMS FOR A MODERN WORLD
1900–18

-

All artists bear the imprint of their time
but the great artists are those in which this stamp
is most deeply impressed

-

Henri Matisse

1908

ASHCAN SCHOOL
c.1900 – c.1915

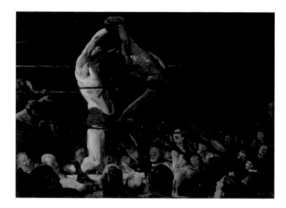

George Bellows
*Both Member's of
This Club*, 1909
Oil on canvas, 115 x
160.5 cm (45¼ x 63¼ in.)
National Gallery of Art,
Washington, DC

**Bellows's painting
of an illegal boxing
match is regarded as a
landmark of twentieth-
century realism.**

'Ashcan School' is a term applied (originally in derision) to American realist painters of the early twentieth century, whose preference in subject matter was for the grittier and seamier aspects of urban life. The group was led by the enormously influential and charismatic Robert Henri, who devoted himself to promoting art with a social purpose. Henri's first converts were originally illustrators for the Philadelphia press: William Glackens, George Luks, Everett Shinn and John Sloan. The skills necessary for pictorial reportage – the ability to capture the fleeting moment, attention to detail and a sharp interest in everyday subject matter – became the hallmarks of their paintings. In 1902 Henri spread his message further afield by moving to New York and setting up an art school. Sloan recalled: 'His teaching was strong stuff in the Nineties of the Victorian era that put "art for art's sake" on a pedestal . . . Henri won us with his robust love for life.'

The major innovations of Henri and the Ashcan School were not in style or technique, but in subject matter and attitude. They were responsible for bringing American art back into contact with life, and for turning a humane gaze on the urban poor, who were either invisible or sentimentalized in academic painting. Their everyday scenes made a strong appeal to the 'common man' and gave new life to a tradition of artistic protest.

KEY ARTISTS

George Bellows (1882–1925), USA
William Glackens (1870–1938), USA
Robert Henri (1865–1929), USA
George Luks (1866–1933), USA
Everett Shinn (1876–1953), USA
John Sloan (1871–1951), USA

KEY FEATURES

Gritty subject matter – prostitutes, street urchins, wrestlers
and boxers
Dark palettes
Realism and social commentary

MEDIA

Painting and print

KEY COLLECTIONS

Butler Institute of American Art, Youngstown, OH, USA
Cleveland Museum of Art, Cleveland, OH, USA
Museum of Fine Arts, Boston, MA, USA
Museum of Modern Art, New York, NY, USA
National Gallery of Art, Washington, DC, USA
Smithsonian American Art Museum, Washington, DC, USA
Springfield Museum of Art, Springfield, OH, USA
Whitney Museum of American Art, New York, NY, USA

George Luks
The Wrestlers, 1905
Oil on canvas, 122.5 ×
168.3 cm (48⅜ ×
66¾ in.)
Museum of Fine Arts,
Boston

**George Luks was famous
for his tall tales and
remarks. 'Guts! Guts!
Life! Life! That's my
technique!' he once
expostulated. 'I can
paint with a shoestring
dipped in pitch and lard.'
It was his combination
of realistic portraiture
and social comment that
outraged many critics.**

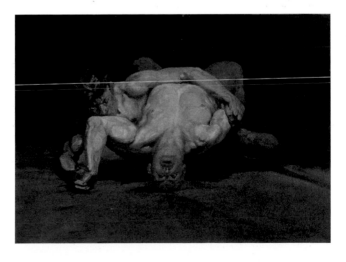

FAUVISM
c.1904–8

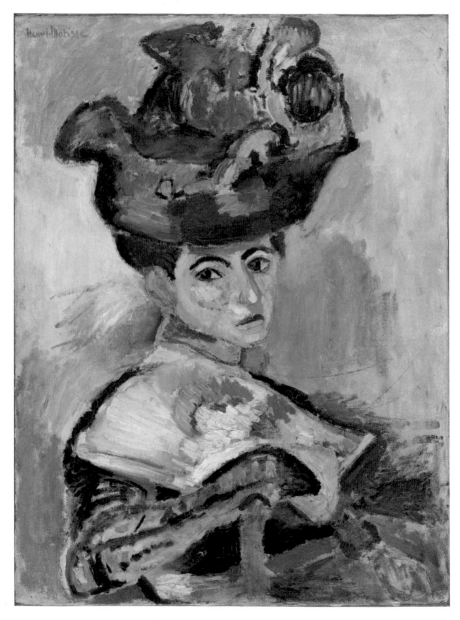

Henri Matisse
Woman with a Hat, 1905
Oil on canvas, 80.7 x
59.7 cm (31¾ x 23½ in.)
San Francisco Museum
of Modern Art, San
Francisco

**Much of the shock value
of Matisse's painting
was due to it being a
portrait of his wife, a
recognizable character,
which drew attention to
the distortion to which
she was subjected.**

In 1905 in Paris, a group of artists exhibited paintings so shocking – the colours so strong and brash, their application so spontaneous and rough – that they were immediately christened *les fauves* (French: wild beasts) by a critic. This group included Henri Matisse, André Derain and Maurice de Vlaminck. Matisse's portrait of his wife, *Woman with a Hat*, was one of the exhibition's key works. With its vibrant, unnatural colours and apparently frenzied brushwork, it caused a scandal. But while the public and critics viewed it with incomprehension, dealers and collectors reacted swiftly and Fauvist work suddenly became the most desirable on the market.

By 1906 the Fauves were regarded as the most advanced painters in Paris. Their dazzling array of brightly coloured landscapes, portraits and figure scenes – traditional subjects interpreted anew – captured the imaginations of enthusiastic collectors in France and abroad. The Fauves' period of dominance in Paris was monumental but brief, as the individual artists went their separate ways and the attention of the art world was eventually diverted to the Cubists. Fauvism was not a coherent movement, but a phase of exhilarating liberation that allowed the artists to pursue their own personal visions of art. Matisse, the 'king of the Fauves', became one of the best-loved and most influential artists of the twentieth century.

KEY ARTISTS
André Derain (1880–1954), France
Henri Matisse (1869–1954), France
Maurice de Vlaminck (1876–1958), France

KEY FEATURES
Bright palette and rough brushstrokes
Subjective use of colour
Colour used to express joy
Decorative surfaces

MEDIA
Painting

KEY COLLECTIONS
Centre Georges Pompidou, Paris, France
Museum of Modern Art, New York, NY, USA
San Francisco Museum of Modern Art, San Francisco, CA, USA
The State Hermitage Museum, St Petersburg, Russia
Tate, London, UK

EXPRESSIONISM
c.1905–20

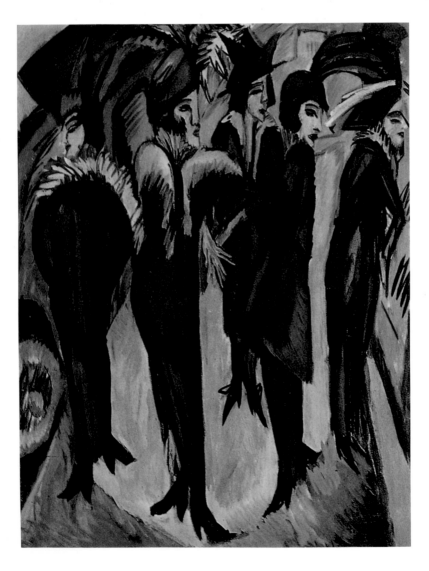

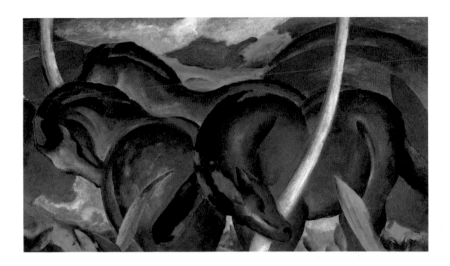

Above: Franz Marc
The Large Blue Horses, 1911
Oil on canvas, 105.5 x 181 cm (41⅝ x 71¼ in.)
Walker Art Center, Minneapolis

Originally a theology student, Marc took up painting as a spiritual activity. Animals were his obsession; in them he saw a purity and communion with nature that man had lost.

Opposite: Ernst Ludwig Kirchner
Five Women in the Street, 1913
Oil on canvas, 120 x 90 cm (47¼ x 35⅜ in.)
Museum Ludwig, Cologne

Here Kirchner has portrayed the women in the picture as menacing creatures, like vultures ready to prey.

Expressionism is a term used to describe art – be it painting, sculpture, literature, theatre, music, dance or architecture – which stresses subjective feelings over objective observations. In its art historical sense, Expressionism filtered into common usage early in the twentieth century, to refer to the new anti-Impressionist tendencies in the visual arts that were developing in different countries from around 1905. These new art forms, which used colour and line symbolically and emotively, were in a sense a reversal of Impressionism: instead of the artist recording an impression of the world around him, the artist impressed his own temperament on his view of the world. This concept of art was so revolutionary that 'Expressionism' became a synonym for 'modern' art in general. In a more specific, categorical sense, Expressionism refers to a particular type of German art developed between 1909 and 1923. Two groups in particular, Die Brücke (The Bridge) and Der Blaue Reiter (The Blue Rider), were the main forces of German Expressionism.

The artists of Die Brücke (Fritz Bleyl, Erich Heckel, Ernst Ludwig Kirchner and Karl Schmidt-Rottluff) were young, idealistic and imbued with the belief that through painting they could create a better world for all. Using simplified drawing, exaggerated forms and bold, contrasting colours, they presented an intense, often harrowing vision of the contemporary world. Emil Nolde joined the group briefly and in his work we see another key theme in Expressionism – mysticism. Nolde's paintings combine simple, dynamic rhythms and dramatic colours to startling effect, and his graphic art, in which he exploits the contrasts of black and white, is particularly powerful and original.

Der Blaue Reiter was a larger and looser association than Die
Brücke and included Russian Vasily Kandinsky, Swiss Paul Klee and
Germans Gabriele Münter, Franz Marc and August Macke, among
others. They were united by an unswerving and passionate belief in
the unfettered creative freedom of the artist to express his personal
vision in whatever form he deemed appropriate. Generally speaking,
their work is more lyrical, spiritual and joyful than that by artists of
Die Brücke.

Oskar Kokoschka and Egon Schiele are the most famous
Austrian Expressionists. Kokoschka's portraits, allegorical scenes
and landscapes are always emotionally turbulent and Schiele
used an aggressive, nervous line to create pictures of emaciated,
twisted, anguished figures. Another important Expressionist
outside Germany was the Frenchman Georges Rouault. In his
early paintings he created intense, compassionate images of
the 'wretched of the earth', while his later work combines moral
indignation and sadness with the hope of redemption.

Expressionism was not confined to two-dimensional art. German
sculptors made figures and portraits combining psychological
intensity with a sense of man's alienation and suffering, while some
architects in Germany and the Netherlands adopted an attitude
and manner that was political, utopian and experimental.

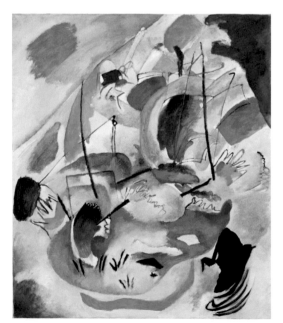

Vasily Kandinsky
*Improvisation 31
(Sea Battle)*, 1913
Oil on canvas, 140.7 x
119.7 cm (55⅜ x 47⅛ in.)
National Gallery of Art,
Washington, DC

**Kandinsky sought a
synthesis of intellect and
emotion and intended his
painting to be as directly
expressive as music.
Although preoccupied
with colour and form, his
paintings between 1912
and 1914 are not fully
abstract – recognizable
shapes draw the viewer's
attention.**

Egon Schiele
Crouching Nude Girl, 1914
Drawing, 31.5 x 48.2 cm
(12⅜ x 19 in.)
Leopold Museum, Vienna

Schiele's works
powerfully express
despair, passion,
loneliness and eroticism.
He relished the role of
tortured artist, writing
to his mother in 1913, 'I
shall be the fruit which
will leave eternal vitality
behind even after its
decay. How great must
be your joy, therefore, to
have given birth to me.'

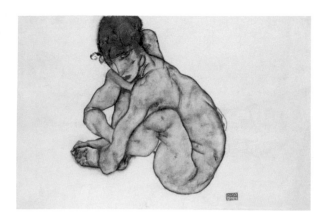

KEY ARTISTS

Erich Heckel (1883–1970), Germany
Vasily Kandinsky (1866–1944), Russia/USSR
Ernst Ludwig Kirchner (1880–1938), Germany
Paul Klee (1879–1940), Switzerland
Oskar Kokoschka (1886–1980), Austria
August Macke (1887–1914), Germany
Franz Marc (1880–1916), Germany
Gabriele Münter (1877–1962), Germany
Emil Nolde (1867–1956), Germany
Georges Rouault (1871–1958), France
Egon Schiele (1890–1918), Austria

KEY FEATURES

Symbolic colours, expressive line and form
Exaggerated imagery
Exaltation of the artist's imagination
Liberation of art from its descriptive role
Emotional, sometimes mystical or spiritual vision
Political, utopian and experimental

MEDIA

All

KEY COLLECTIONS

Albertina, Vienna, Austria
Brücke-Museum, Berlin, Germany
Kunstmuseum, Basel, Switzerland
Leopold Museum, Vienna, Austria
Neue Galerie New York, New York, NY, USA
Nolde Foundation, Seebüll, Germany
Stedelijk Museum, Amsterdam, Netherlands
Tate, London, UK

CUBISM
c.1908–14

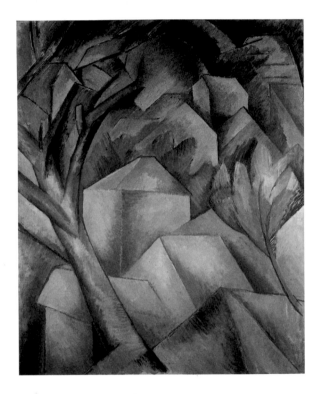

Georges Braque
Houses at l'Estaque, 1908
Oil on canvas, 73 x 60
cm (28¾ x 23½ in.)
Kunstmuseum Bern, Bern

This rural scene is an example of Braque's Analytical Cubism, with its muted colours, fragmented shapes and multiple viewpoints.

Cubism was invented by Pablo Picasso and Georges Braque after they met in Paris in 1907. The two worked closely together to develop the revolutionary new style, which a critic noted reduced 'everything, landscape and figures and houses, to geometric patterns, to cubes'. Cubism soon became the official, and lasting, name for the movement.

For both artists Cubism was a type of realism, one that conveyed the 'real' more convincingly than the various types of illusionistic representation dominant in the west since the Renaissance. They rejected a single-point perspective and abandoned the decorative qualities of previous avant-gardes such as the Impressionists and the Fauves. Instead, they looked to two alternative sources: Paul Cézanne's later paintings (for structure) and African sculpture (for its abstracted geometric and symbolic qualities). For Picasso, the

Pablo Picasso
*Still Life with Chair
Caning*, 1912
Oil and pasted oilcloth
on canvas, oval with rope
around edge, 29 x 37 cm
(11⅜ x 14½ in.)
Musée Picasso, Paris

**This collage plays with
notions of the real and
the illusory. Here the 'real
object' stuck to the canvas
turns out to be itself an
illusion, not actual chair
caning but a piece of oil
cloth machine-printed
with a caning-like pattern.
The letters 'JOU' stand
for *journal* (French:
newspaper), which itself
stands for the newspaper
one might find on a
café table. The whole is
surrounded with a piece
of rope which both frames
the still life as an art work,
and simultaneously calls
attention to the picture's
existence as an object.**

challenge of Cubism was to represent three dimensions on a two-dimensional canvas. For Braque, it was to explore ways of depicting volume and mass in space.

The first phase of Cubism, called Analytical Cubism, lasted until around 1911. The artists used subdued colours and neutral subject matter, which they reduced and fragmented into quasi-abstract compositions of interpenetrating planes. Objects are suggested rather than described, and viewers must construct them by thought as well as by sight. Abstraction was not the goal, however, but a means to an end. As Braque confirmed, fragmentation was 'a technique for getting closer to the object'.

During the next phase (1912–14), called Synthetic Cubism, Braque and Picasso reversed their working procedure: instead of reducing objects and space towards abstraction, they built up pictures from fragmented abstractions. As the young artist Juan Gris, who joined the older artists at this stage, explained: 'I can make a bottle from a cylinder.' Two major innovations, both considered landmarks of modern art, occurred in 1912. Picasso created the first Cubist collage (from the French verb *coller*: to stick on), *Still Life with Chair Caning*, and all three artists produced *papier collés* (compositions of cut-out pasted papers). These works generally include a clearer subject, richer colours, readymade fragments from the 'real world' and text.

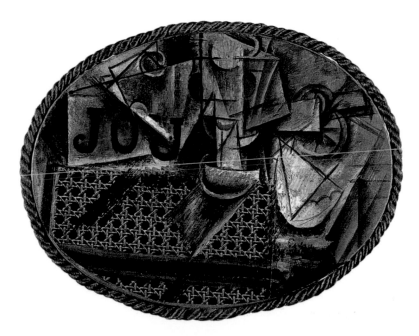

By 1912 Cubism had spread across the world and its revolutionary methods rapidly served as a catalyst for other styles and movements, including Expressionism, Futurism, Constructivism, Dada, Surrealism and Precisionism. While Picasso, Braque and Gris did not themselves pursue the angle towards abstraction, others did, such as the Orphists, Synchromists, Rayonists and Vorticists. Cubist ideas were also quickly absorbed and adapted by those working in other disciplines such as sculpture, architecture and the applied arts. Cubist sculpture grew out of collage and *papier collé*, and fed into assemblage, which took collage into three dimensions. The new techniques liberated sculptors to use new non-human subject matter and prompted them to think of sculptures as built, not just modelled or carved, objects.

Juan Gris
Newspaper and Fruit Dish, 1916
Oil on canvas, 92 x 60 cm (36¼ x 23⅝ in.)
Yale University Art Gallery, New Haven

Gris was the purest exponent of Synthetic Cubism. His still lifes examine the object from every angle, exposing systematically horizontal and vertical planes.

KEY ARTISTS

Georges Braque (1882–1963), France
Marcel Duchamp (1887–1968), France
Juan Gris (1887–1927), Spain
Fernand Léger (1881–1955), France
Pablo Picasso (1881–1973), Spain

KEY FEATURES

Use of multiple viewpoints and shifting space
Interweaving planes and lines
Forms fragmented into geometric patterns, or 'cubes'
Fragments used to create objects
Use of collaged real elements

MEDIA

Painting, sculpture, architecture and applied arts

KEY COLLECTIONS

Museum of Czech Cubism, Prague, Czech Republic
Kunstmuseum Bern, Bern, Switzerland
Musée Picasso, Paris, France
Museum of Modern Art, New York, NY, USA
National Gallery of Art, Washington, DC, USA
Neue Nationalgalerie, Berlin, Germany
Solomon R. Guggenheim Museum, New York, NY, USA
Tate, London, UK
Thyssen-Bornemisza Museum, Madrid, Spain
Yale University Art Gallery, New Haven, CT, USA

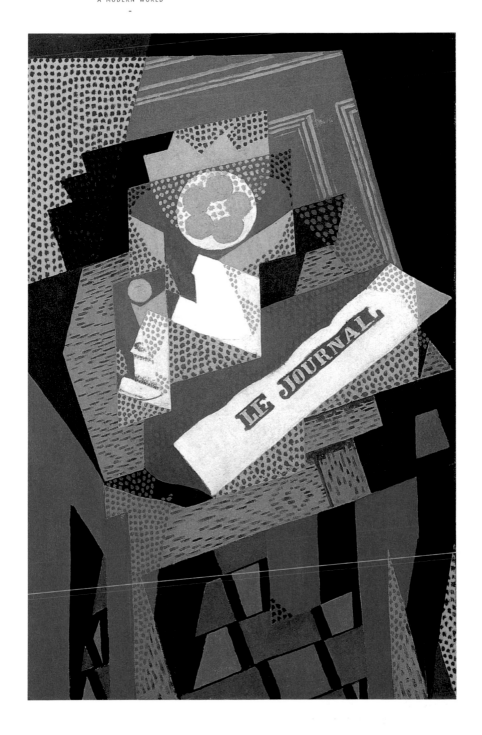

FUTURISM
1909 – c.1930

Futurism was announced to the world in 1909 by flamboyant
Italian poet Filippo Tommaso Marinetti with a bombastic manifesto
published on the front page of a Paris newspaper, indicating his intent
that this would not be a provincial Italian development, but one of
worldwide importance. Initiated as a literary reform movement that
rejected any notion of historical tradition, Futurism soon expanded
to embrace other disciplines as young Italian artists enthusiastically
answered Marinetti's call to arms. Manifestos for painting, sculpture,
film, music, poetry, architecture, women and flight followed. The
'Futurist Reconstruction of the Universe' even proposed the creation
of a more abstract Futurist style to be applied to fashion, furnishings,
interiors – in fact, to a whole way of life. The unifying principle was a
passion for speed, power, new machines and technology, and a desire
to convey the 'dynamism' of the modern industrial city.

The Futurists' preoccupation with breaking from the past insisted
on a new mode of representation. Contact with the Cubists in Paris
proved a turning point. Futurists subsequently used Cubist geometric

Giacomo Balla
*Girl Running on a
Balcony*, 1912
Oil on canvas, 125 x 125
cm (49¼ x 49¼ in.)
Civica Galleria d'Arte
Moderna, Milan

**Balla experimented with
new ways of depicting
movement and was
greatly influenced by
photographic studies,
superimposing a
succession of images. His
work tended increasingly
towards abstraction.**

Umberto Boccioni
*Unique Forms of
Continuity in Space,* 1913
Bronze, 117.5 x 87.6 x
36.8 cm (43⅞ x
34⅞ x 15¾ in.)
Private collection

**Boccioni, whose paintings
had already earned him
considerable distinction,
turned his attention to
sculpture in 1912, saying:
'Let us discard the finite
line and the closed form
stature. Let us tear the
body open.'**

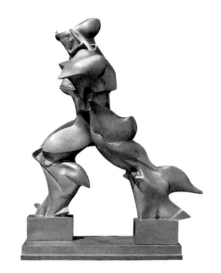

forms and intersecting planes combined with complementary
colours – in a sense, putting Cubism into motion. Although primarily
an Italian movement, and though short-lived, Futurist theory and
iconography had a lasting impact on the international avant-garde.

KEY ARTISTS
Giacomo Balla (1871–1958), Italy
Umberto Boccioni (1882–1916), Italy
Carlo Carrà (1881–1966), Italy
Filippo Tommaso Marinetti (1876–1944), Italy
Gino Severini (1883–1966), Italy

KEY FEATURES
Use of colour, line, light and form to convey the excitement,
 speed and movement of modern urban life

MEDIA
All

KEY COLLECTIONS
Depero Museum, Rovereto, Italy
Estorick Collection of Modern Italian Art, London, UK
Museo del Novecento, Milan, Italy
Museum of Modern Art, New York, NY, USA
Peggy Guggenheim Collection, Venice, Italy
Pinocoteca di Brera, Milan, Italy
Tate, London, UK

SYNCHROMISM

1913 – c.1918

Synchromism (meaning 'with colour', derived from Greek) was
a style of painting invented by two American painters, Morgan
Russell and Stanton Macdonald-Wright. They drew on the
structural principles of Cubism and the colour theories of the
Neo-Impressionists in their experiments in colour abstraction. Like
their contemporaries, they strove to formulate a system in which
meaning did not rely on resemblance to objects in the outside world,
but was derived from the results of colour and form on canvas.

Russell was also a musician and his aim was to orchestrate
colour and form into harmonious compositions like those in musical
symphonies. The musical analogy, and other Synchromist features,
are visible in Russell's monumental painting *Synchromy in Orange:
To Form* (1913–14). Cubist structures are enlivened by chromatic
combinations and free-flowing rhythms and arcs, which create a
sense of dynamism.

The Synchromists exhibited in Munich, Paris and New York in
1913 and 1914, causing uproar and controversy. They exerted an
enormous influence on other American artists, however, such as
Thomas Hart Benton, Patrick Henry Bruce and Arthur B. Davies,
who were all called Synchromists at some point in their careers.
By the end of the First World War Synchromism had almost entirely
died out, with many of its practitioners returning to figuration.

Morgan Russell
*Synchromy in Orange:
To Form*, 1913–14
Oil on canvas,
343 x 308.6 cm
(135 x 121½ in.)
Albright-Knox Art
Gallery, Buffalo

**This enormous painting
is a non-representational,
purely abstract picture.
The entire canvas is
covered with geometric
forms in a wild variety
of colours.**

KEY ARTISTS
Stanton Macdonald-Wright (1890–1973), USA
Morgan Russell (1886–1953), USA

KEY FEATURES
Vivid colours and geometric shapes
Free-flowing rhythms and arcs
Abstract, non-representational
A sense of movement and dynamism

MEDIA
Painting

KEY COLLECTIONS
Albright-Knox Art Gallery, Buffalo, NY, USA
Montclair Art Museum, Montclair, NJ, USA
Munson-Williams-Proctor Arts Institute, New York, NY, USA
Weisman Art Museum, Minneapolis, MN, USA
Whitney Museum of American Art, New York, NY, USA

ORPHISM
1913 – c.1918

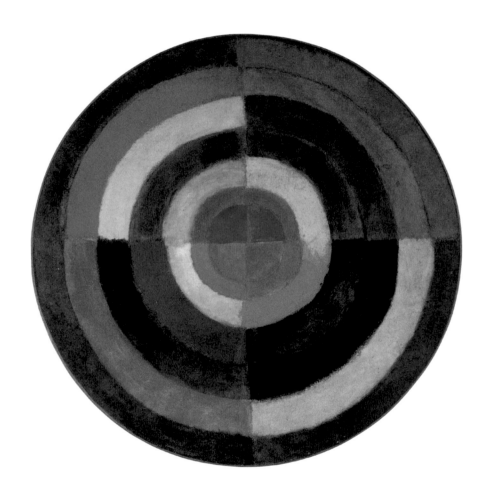

Orphism – or Orphic Cubism – was a term coined by French critic-poet Guillaume Apollinaire in 1913 to describe what he saw as a 'movement' within Cubism. Unlike monochromatic Cubist works, these new abstract paintings were bright lozenges and swirls of saturated colour dissolving into each other. Orphism referred to the myth of Orpheus, the legendary Greek poet and lyre-player, whose music could tame wild beasts. For Apollinaire this term conveyed the musical, spiritual quality of these harmonious compositions that furthered the fragmentation of Cubism through colour.

The two painters most enduringly associated with Orphism are French painter Robert Delaunay and his Russian wife, Sonia. Both were pioneers of colour abstraction. Robert studied Neo-Impressionism, optics and the interrelationships of colour, light and movement, and produced works such as *Simultaneous Contrasts: Sun and Moon* (1913), in which the principal means of expression lies in the composition of colour rhythms. Apollinaire called Delaunay's pictures 'coloured Cubism', but Delaunay coined his own term, 'Simultanism', to describe his style. Between 1912 and 1914 Sonia made her first abstract paintings in the Orphist style. Typically working in many different media, she also made collages, book bindings and illustrations, and clothing, taking the new abstract style into the applied arts.

Robert Delaunay
Le Premier Disque,
1913–14
Oil on canvas, 134 cm
(52¾ in.) diameter
Private collection

Delaunay used colour to create rhythmic relationships within near-abstract compositions. He described his paintings as 'simultaneous contrasts', in conscious reference to terms used by French chemist and colour theorist M. E. Chevreul.

KEY ARTISTS
Robert Delaunay (1885–1941), France
Sonia Delaunay (1885–1979), Russia-France
František Kupka (1871–1957), Czechoslovakia

KEY FEATURES
Abstract compositions
Bright colours
Swirling shapes

MEDIA
Painting and applied arts

KEY COLLECTIONS
National Gallery in Prague, Prague, Czech Republic
Musée Nationale d'Art Moderne, Paris, France
Museum of Modern Art, New York, NY, USA
Solomon R. Guggenheim Museum, New York, NY, USA
Philadelphia Museum of Art, Philadelphia, PA, USA

RAYONISM
1913–17

Rayonism, or Rayism (from the Russian *luch*: ray), was launched by husband-and-wife painter-designers Mikhail Larionov and Natalia Goncharova in Moscow in 1913 with an exhibition entitled 'The Target'. Like many of their contemporaries throughout the world, the Rayonists were engaged in the adventure of creating an abstract art complete with its own terms of reference. In the Rayonist manifesto that followed, Larionov explained that Rayonist paintings depict not objects but the intersection of rays reflected from them.

Larionov and Goncharova had previously been instrumental in the Russian avant-garde, promoting a unique fusion of western avant-garde developments and native Russian folk art. Rayonism was also a fusion, as Larionov freely acknowledged, 'of Cubism, Futurism and Orphism' combined with his interest in science, optics and photography.

Larionov and Goncharova's work quickly became well known in Russia and Europe between 1912 and 1914. By the time of the 1917 Revolution in Russia, Larionov and Goncharova had settled in Paris, abandoned Rayonism in favour of their more 'primitive' style and turned their attention to designing costumes and sets for dance productions. Though short-lived, Rayonist work and theory proved influential on the next generation of avant-garde Russian artists, and was instrumental in the development of abstract art in general.

Natalia Goncharova
Rayonist Dancer,
c.1916
Oil on canvas, 50 x 42
cm (19⅝ x 6½ in.)
Private collection

Goncharova shared the Futurist passion for machines and mechanized movement. She and Larionov published a Rayonist manifesto, which had a profound affect on subsequent Russian avant-garde artists.

KEY ARTISTS
Natalia Goncharova (1881–1962), Russia
Mikhail Larionov (1881–1964), Russia

KEY FEATURES
Colourful, intersecting slanting lines
Dynamic lines and sharp angles

MEDIA
Painting

KEY COLLECTIONS
Centre Georges Pompidou, Paris, France
Museum Ludwig, Cologne, Germany
Museum of Modern Art, New York, NY, USA
Solomon R. Guggenheim Museum, New York, NY, USA
Tate, London, UK

SUPREMATISM
1913 – c.1920

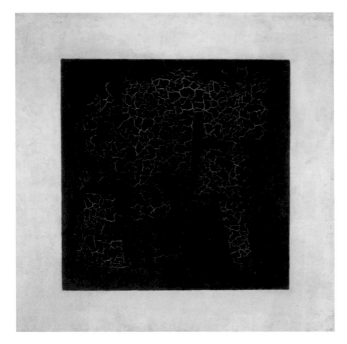

Kazimir Malevich
Black Square, 1915
Oil on canvas, 79.5 x 79.5
cm (31¼ x 31¼ in.)
The State Tretyakov
Gallery, Moscow

**Malevich's *Black Square*
was hung like an icon
across the corner of
the gallery when it
was exhibited at the
'0-10' exhibition in St
Petersburg in 1915.**

Suprematism was an art of pure geometrical abstraction invented by Russian painter Kazimir Malevich between 1913 and 1915. He believed that the making and reception of art was an independent spiritual activity, divorced from any notions of political, utilitarian or social purpose. He felt this mystical 'sensation' could be best conveyed by the essential components of painting – purified form and colour.

The public debut of Suprematism was at an exhibition in St Petersburg in 1915 that included Malevich's famous *Black Square* (1915). Malevich described the black square as the 'zero of form' and the white background as 'the void beyond this feeling'. After his initial works of simple geometric shapes painted in black, white, red, green and blue, he began to include more complicated shapes and a broader range of colours and shadows, creating an illusion of space and movement as the elements seem to float in front of the canvas.

Kazimir Malevich
Suprematism, 1915
Oil on canvas, 805 x
71 cm (317 x 28 in.)
The State Russian
Museum, St Petersburg

**Malevich's paintings
gathered an extraordinary
following. Despite their
radical idiom, their
paint-on-canvas mode
of representation roots
them in a traditional
form, distinct from
Constructivism's
'culture of materials'.**

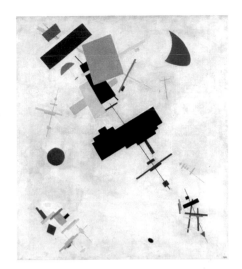

Suprematism attracted many followers and, despite Malevich's resistance to the idea that art and politics could go together, the movement flourished for a time after the October Revolution of 1917. Malevich's insistence on 'pure art' soon fell out of favour, however, as artists turned to utilitarian art and industrial design. Suprematism was superseded first by Constructivism, then, as the period of state support for experimental abstract art came to an end in the late 1920s, by Socialist Realism.

KEY ARTISTS
El Lissitzky (1890–1941), Russia/USSR
Kazimir Malevich (1878–1935), Russia/USSR
Lyubov Popova (1889–1924), Russia/USSR
Olga Rozanova (1886–1918), Russia/USSR
Nadezhda Udaltsova (1886–1961), Russia/USSR

KEY FEATURES
Geometric abstraction
Simple motifs
Non-representational

MEDIA
Painting and applied arts

KEY COLLECTIONS
Museum of Modern Art, New York, NY, USA
Stedelijk Museum, Amsterdam, Netherlands
The State Russian Museum, St Petersburg, Russia
The State Tretyakov Gallery, Moscow, Russia

CONSTRUCTIVISM
1913 – c.1930

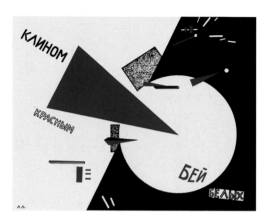

Constructivism was another Russian art movement based on the use of geometric shapes. It was instigated by Vladimir Tatlin, who exhibited his radical abstract geometric painting-reliefs and corner counter-reliefs in St Petersburg in 1915, in the same exhibition that launched Kazimir Malevich's Suprematism. These extraordinary assemblages were made from industrial materials – such as metal, glass, wood and plaster – and incorporated 'real' three-dimensional space as a sculptural material. Although their work shares certain visual characteristics – both are abstract and geometric – Malevich and Tatlin held opposing ideas about the role of art. Malevich believed that art was a separate activity without social or political obligations, while Tatlin believed that art could, and should, have an impact on society.

By the time of the Bolshevik Revolution in 1917 Tatlin had been joined by a number of other artists who were also keen to be involved in the creation of the new society. The early and mid-1920s were the heyday of Constructivism, when it ousted Suprematism as the leading style in Soviet Russia. Constructivist artists devoted themselves to designing everything from furniture and typography to ceramics, costumes and buildings. The reign of Constructivism as the unofficial style of the Communist state had ended by the late 1920s, when Socialist Realism was prescribed as the official style of Communism. By this time, however, exiles had already spread the gospel of the Russian abstract movements throughout the world.

El Lissitzky
Beat the Whites with the Red Wedge, 1919–20
Lithographic poster, 48.8 x 69.2 cm (19¼ x 27¼ in.)
Private collection

Lissitzky's famous civil war propaganda poster delivers its starkly legible message with simple but powerful graphic symbols.

Vladimir Tatlin
*Model for the
Monument to the
Third International*, 1919
Contemporary
photograph of wood
and metal model
Nationalmuseum,
Stockholm

Tatlin can be seen
smoking a pipe in front
of the model for his
monument. This was an
audacious and visionary
design for an enormous
iron spiral tower with a
high-tech information
centre that included
open-air screens to
transmit news and
propaganda and a facility
for projecting images
onto clouds. It was never
realized – it could not
have been built in the
technologically backward
Soviet Union. However,
the concept still stands
as a powerful, if poignant,
monument to both the
utopian Soviet dream and
to the passionate belief
that the modern artist-
engineer could play an
integral role in fashioning
such a society.

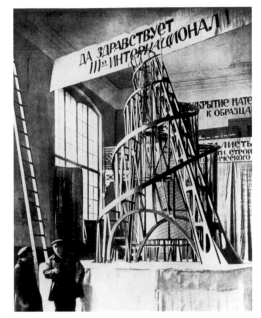

KEY ARTISTS

Naum Gabo (Naum Neemia Pevsner; 1890–1977), Russia/USSR
El Lissitzky (1890–1947), Russia/USSR
Antoine Pevsner (1884–1962), Russia/USSR
Lyubov Popova (1889–1924), Russia/USSR
Alexander Rodchenko (1891–1956), Russia/USSR
Varvara Stepanova (1894–1958), Russia/USSR
Vladimir Tatlin (1885–1953), Russia/USSR
Alexander Vesnin (1883–1959), Russia/USSR

KEY FEATURES

Abstract, geometrical forms

MEDIA

Painting, sculpture, design and architecture

KEY COLLECTIONS

Moderna Museet, Stockholm, Sweden
Museum of Modern Art, New York, NY, USA
The State Russian Museum, St Petersburg, Russia
The State Tretyakov Gallery, Moscow, Russia
Van Abbemuseum, Eindhoven, Netherlands

PITTURA METAFISICA
1913 – c.1920

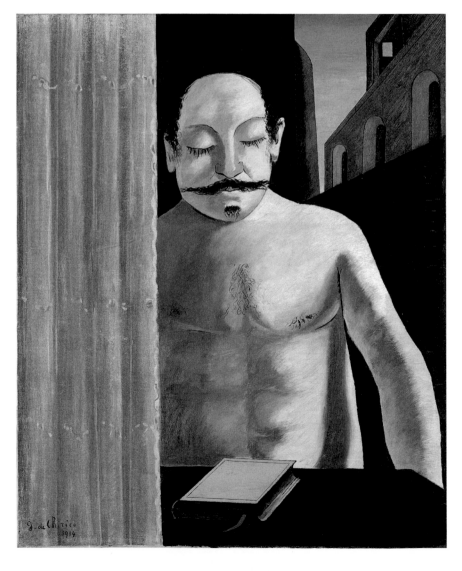

Pittura Metafisica (Italian: Metaphysical painting) is the name given to the style of painting developed from around 1913 by Giorgio de Chirico and, later, the former Futurist Carlo Carrà. In contrast to the noise and movement of Futurist works, Metaphysical paintings are quiet and still. They are recognizable by a number of typical characteristics: architectural scenes with classical trimmings and distorted perspectives; incongruous objects juxtaposed together; and, above all, their disquieting air of mystery.

The Metaphysical painters believed in art as prophecy and in the artist as the poet-seer who, in 'clear-sighted' moments, could remove the mask of appearances to reveal the 'true reality' hidden behind. They were fascinated by the eeriness of everyday life and aimed to create an atmosphere that captured the extraordinary of the ordinary.

Carrà and de Chirico met in 1917 at the military hospital in Ferrara, Italy, where both were recovering from nervous breakdowns, and began to work closely together. This lasted only until around 1920, when the artists split over an acrimonious argument about which one of them had initiated the movement. By that time, however, their pictures were well known and their style influential, especially for the Surrealists in Paris.

Giorgio de Chirico
The Child's Brain, 1914
Oil on canvas, 80 x 65 cm (31⅛ x 25⅝ in.)
Moderna Museet, Stockholm

The Metaphysical painters aimed to transcend the physical appearance of reality, to unnerve or surprise the viewer with indecipherable or enigmatic images. This painting was a favourite of Surrealism's founder, André Breton, who hailed De Chirico as a precursor of Surrealism.

KEY ARTISTS
Carlo Carrà (1881–1966), Italy
Giorgio de Chirico (1888–1978), Italy
Giorgio Morandi (1890–1964), Italy

KEY FEATURES
Quiet, still, eerie, mysterious
Architectural scenes with classical trimmings
Incongruous objects juxtaposed
Odd perspectives

MEDIA
Painting

KEY COLLECTIONS
Moderna Museet, Stockholm, Sweden
Museo del Novecento, Milan, Italy
Museum of Modern Art, New York, NY, USA
Peggy Guggenheim Collection, Venice, Italy
Tate, London, UK

VORTICISM

1914 – c.1918

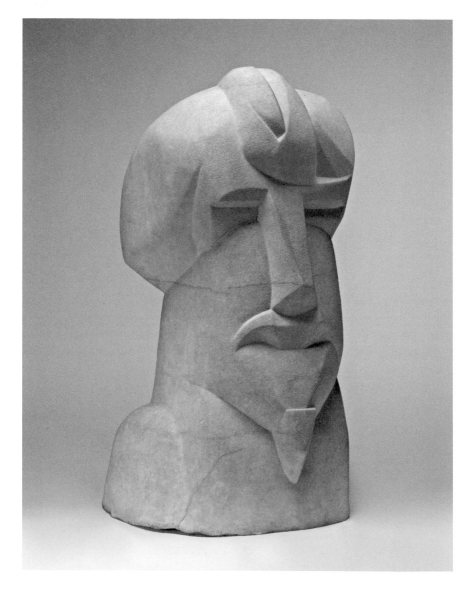

Vorticism (derived from the word 'vortex') was founded in 1914 by writer and painter Wyndham Lewis to reinvigorate British art with an indigenous movement intended to rival continental European Cubism, Futurism and Expressionism.

Lewis and those who joined him wanted to drag British art out of the past and create a contemporary, edgy abstraction that related to the world around them. The Vorticists wanted their art to embrace 'the forms of machinery, factories, new and vaster buildings, bridges and works'. They employed an angular style and machine-like forms, but not overt machine imagery (as did the American Precisionists).

Almost immediately engulfed by the onset of the First World War, Lewis and his colleagues nevertheless managed to produce an impressive body of work, which included paintings characterized by slashing blocks of colour, mechanical and alien sculptures, and writings in which unbounded scorn mingled with passionate enthusiasm. A number of artists served as official war artists and applied the geometrical style to unflinching portrayals of the tragedies of war. Although brief in duration, Vorticism made its mark as part of the modern movement and laid the ground for future developments in British abstract art.

Henri Gaudier-Brzeska
Hieratic Head of Ezra Pound, 1914
Marble, 90.5 x 45.7 x 48.9 cm (35⅝ x 18 x 19¼ in.)
National Gallery of Art, Washington, DC

The American Modernist poet Ezra Pound was an important ally of the Vorticists and christened the new movement 'Vorticism', declaring that the vortex was 'the point of maximum energy'. He commissioned this commanding portrait from Gaudier-Brzeska, requesting that he look 'virile'.

KEY ARTISTS

David Bomberg (1890–1957), UK
Jacob Epstein (1880–1959), USA–UK
Henri Gaudier-Brzeska (1891–1915), France
Wyndham Lewis (1882–1957), UK
Christopher (C. R. W.) Nevinson (1889–1946), UK

KEY FEATURES

Hard, angular
Geometric
Machine aesthetic

MEDIA

Painting, sculpture and literature

KEY COLLECTIONS

Kettle's Yard, Cambridge, UK
Imperial War Museum, London, UK
Museum of Modern Art, New York, NY, USA
Phillips Collection, Washington, DC, USA
Tate, London, UK

DADA
1916–22

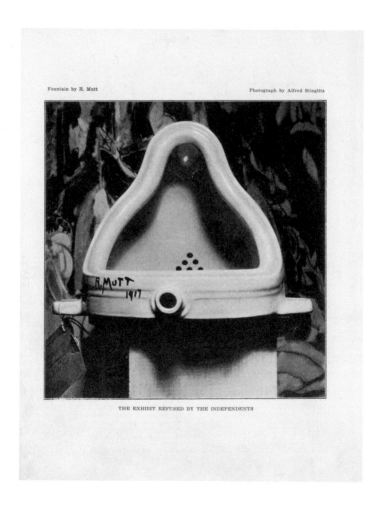

Fountain by R. Mutt

Photograph by Alfred Stieglitz

THE EXHIBIT REFUSED BY THE INDEPENDENTS

Dada was an international, multi-disciplinary phenomenon, as much a mindset as an art movement. It developed during and after the First World War as young artists banded together to express their anger with the war. They believed that the only hope for society was to destroy systems based on reason and logic and replace them with ones based on anarchy, the primitive and the irrational.

The word 'dada' was chosen at random from a dictionary in Zurich in 1916. Meaning 'yes, yes' in Romanian, 'hobby-horse' in French and 'goodbye' in German, the term was adopted by the artists for its internationalism, absurdity and simplicity. Through absurdist provocations, whether aggressive or irreverent, they challenged the status quo via satire, irony, games and word play.

Marcel Duchamp's 'readymades' – everyday, industrially manufactured objects, selected and exhibited as art with little or no alteration – assert that art can be made from anything. His infamous *Fountain* (1917) – a porcelain urinal displayed upside down and signed 'R. Mutt' – takes the art world to task for its supposed open-mindedness, while simultaneously making a pointed commentary on the weight a signature has in the valuation of a work of art. The Dadaist presentation of art as idea and its questioning of societal and artistic mores changed irrevocably the course of art.

Marcel Duchamp
Fountain, 1917
Photograph of porcelian urinal by Alfred Stieglitz from *Blind Man*, published May 1917
Beinecke Rare Book and Manuscript Library, Yale University, New Haven

Duchamp dubbed manufactured objects presented as art 'readymades'. The Dadaist practice of dislocating objects from their familiar context and displaying them as art radically challenged artistic convention.

KEY ARTISTS

Jean Arp (1886–1966), France–Germany
Marcel Duchamp (1887–1968), France–USA
Hannah Höch (1889–1979), Germany
Francis Picabia (1879–1953), France–Cuba
Man Ray (1890–1976), USA
Kurt Schwitters (1887–1948), Germany

KEY FEATURES

Absurdist, provocative
Deliberately shocking
Use of chance and readymades

MEDIA

Demonstrations, poetry readings, noise concerts, exhibitions and manifestos
Collage, photomontage and assemblage

KEY COLLECTIONS

Centre Georges Pompidou, Paris, France
Henie Onstad Art Centre, Høvikodden, Norway
Janco Dada Museum, Ein Hod Artists' Village, Hof Hacarmel, Israel
Museum of Modern Art, New York, NY, USA
Neue Galerie New York, New York, NY, USA
Philadelphia Museum of Art, Philadelphia, PA, USA
Tate, London, UK

DE STIJL
1917 – c.1924

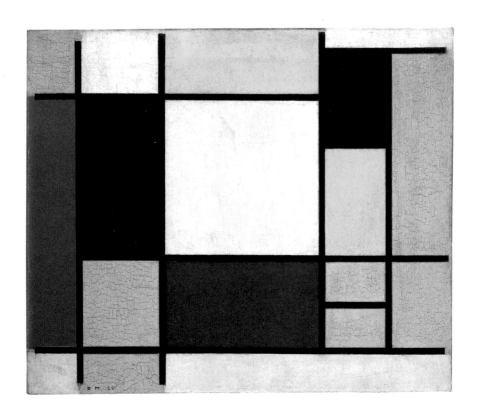

De Stijl (Dutch: The Style) was an alliance of artists, architects and designers brought together by Theo van Doesburg in 1917. The group's mission was to create a new art in the spirit of peace and harmony. They believed that the reduction – the purification – of art to its basics (form, colour and line) would in turn lead to a renewal of society, and that when art was fully integrated into life it would no longer be necessary.

De Stijl paintings are composed of horizontal and vertical lines, right angles, and rectangular areas of flat colours. The palette is reduced to the primary colours of red, yellow and blue, and the neutral colours of white, black and grey. De Stijl architecture shows a similar clarity, austerity and order, taking the geometric abstract language of straight lines, right angles and clean surfaces into three dimensions. Gerrit Rietveld's extraordinary Schröder House in Utrecht (1924) is in many ways the masterpiece of the whole De Stijl movement. Here, the goal of creating a total living environment was achieved and the overall effect of the play between the lines, angles and colours is that of living in a De Stijl painting. De Stijl's influence was immense, and continues to affect artists, designers and architects today.

Piet Mondrian
Composition in Red, Black, Blue, Yellow and Grey, 1920
Oil on canvas, 51.5 x 61 cm (20¼ x 24 in.)
Stedelijk Museum, Amsterdam

Mondrian explored and refined his conception of pure colour and form in his work and writings, becoming one of the most important artists of the first half of the twentieth century and an important touchstone for all abstract artists.

KEY ARTISTS AND ARCHITECTS
Piet Mondrian (1872–1944), Netherlands
Gerrit Rietveld (1888–1964), Netherlands
Theo van Doesburg (1884–1931), Netherlands

KEY FEATURES
Primary colours and right angles
Simplified line and form
Geometric abstraction

MEDIA
Painting, applied arts and architecture

KEY COLLECTIONS
Gemeentemuseum, The Hague, Netherlands
Kröller-Müller Museum, Otterlo, Netherlands
Museum of Modern Art, New York, NY, USA
Stedelijk Museum, Amsterdam, Netherlands
Tate, London, UK

PURISM
1918–26

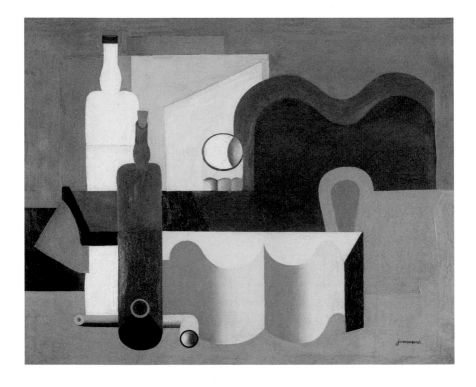

Purism was a post-Cubist movement launched in 1918 by French painter Amédée Ozenfant and Swiss-born painter, sculptor and architect Charles-Édouard Jeanneret, better known by his pseudonym, Le Corbusier. The two were disillusioned with what they saw as the decline of Cubism into a form of elaborate decoration. They were inspired by the purity and beauty they found in machine forms, and were guided by their belief that classical numerical formulas could produce a sense of harmony and, consequently, joy.

The subjects of their paintings – such as everyday objects and musical instruments – were Cubist, but more recognizable in their new Purist incarnations. Strongly composed images of shape-related objects with strong contours were shown in two clear views – depth and silhouette – and were painted in subdued colours in a smooth, cool fashion.

The two artists' unswerving conviction that order is a basic human need led them to develop an all-encompassing Purist aesthetic that embraced architecture and product design as well as painting. It developed into a missionary campaign for a new functional style from which ornament would be purged. By the time Ozenfant and Le Corbusier began to move apart, around 1926, Purist ideas – some of the most important formative influences on modern architecture and design – had already been disseminated.

Le Corbusier
Purist Still Life, 1922
Oil on canvas, 65 x 81 cm (25⅝ x 31⅞ in.)
Musée National d'Art Moderne, Centre Georges Pompidou, Paris

In their essay on Purism published in 1921, Ozenfant and Le Corbusier wrote: 'We think of the painting not as a surface, but as a space ... an association of purified, related and architectured elements.'

KEY ARTISTS

Le Corbusier (Charles-Édouard Jeanneret; 1887–1965), Switzerland
Amédée Ozenfant (1886–1966), France

KEY FEATURES

Simple geometry
Strong contours
Subdued colours

MEDIA

Painting, design and architecture

KEY COLLECTIONS

Centre Georges Pompidou, Paris, France
Museum of Modern Art, New York, NY, USA
Öffentliche Kunstsammlung, Basel, Switzerland
Solomon R. Guggenheim Museum, New York, NY, USA

SEARCH FOR
A NEW ORDER
1918–45

-

**The picture is a machine for
the transmission of sentiments**

-

Amédée Ozenfant and Le Corbusier

1918

SCHOOL OF PARIS
c.1918–c.1940

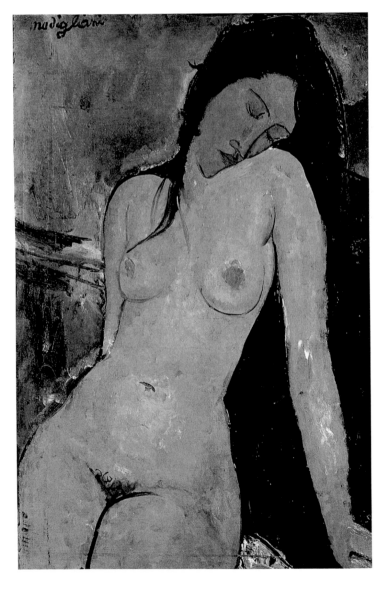

'School of Paris' is a term used to refer to the extraordinary international community of Modernist artists living and working in Paris during the first half of the twentieth century. It acknowledges Paris as the centre of the art world (until the Second World War) and as a symbol of cultural internationalism. Artists who do not conveniently fit into a specific category are often included, such as sculptors Julio Gonzalez and Constantin Brancusi, and painters Amedeo Modigliani, Chaim Soutine and Marc Chagall.

Catalan Gonzalez is known for his quirky metal constructions and Romanian Brancusi for his exquisitely refined sculptures, which are simplified almost to the point of abstraction. Italian Modigliani painted hypnotic, elegant, elongated portraits and nudes, while Russian Soutine's intense colours and violently expressive brushwork mark him as a kindred spirit of the early Expressionists. While Soutine's paintings express an inner turbulence and anguish, the paintings of another School of Paris painter, Soutine's friend and countryman Marc Chagall, could not be more different. His synthesis of Fauvist colour, Cubist space and images from Russian folklore and his own imagination produced fantastic paintings lyrically expressing his love of life and humanity.

Amedeo Modigliani
Female Nude, c.1916
Oil on canvas, 92.4 x 59.8 cm (36⅜ x 23½ in.)
Courtauld Gallery, London

Modigliani's life is the stuff of legend. His poverty and illness, exacerbated by drugs and alcohol, and his drunken exhibitionism and fights with his girlfriends are almost as well known as his elegant, hypnotic portraits and nudes.

KEY ARTISTS

Constantin Brancusi (1876–1957), Romania
Marc Chagall (1887–1985), Russia/USSR
Julio Gonzalez (1876–1942), Spain
Amedeo Modigliani (1884–1920), Italy
Chaim Soutine (1894–1943), Russia

KEY FEATURES

Pluralism of styles
Cross-fertilization of ideas between artists

MEDIA

Painting, sculpture and photography

KEY COLLECTIONS

Art Institute of Chicago, Chicago, IL, USA
Centre Georges Pompidou, Paris, France
J. Paul Getty Museum, Los Angeles, CA, USA
Musée de l'Orangerie, Paris, France
Museo del Novecento, Milan, Italy
National Gallery of Art, Washington, DC, USA

BAUHAUS
1919–33

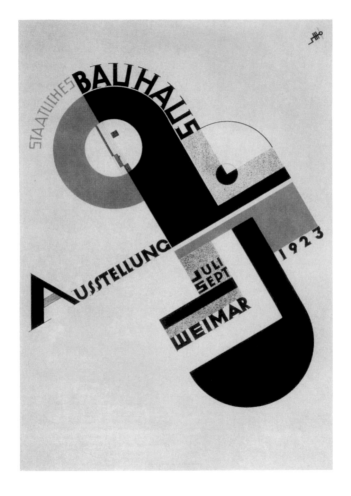

The Bauhaus (German: house for building, growing, nurturing) was
a school established in Weimar, Germany, in 1919. Director Walter
Gropius aimed to make artists, designers and architects more
socially responsible and to reunite creativity and manufacturing.
To realize his vision, Gropius gathered around him an extraordinary
group of artist-teachers, including Paul Klee, Oskar Schlemmer
and Vasily Kandinsky. Gropius believed that together they could

combine architecture, painting and sculpture into a new form that would lead to the betterment of society.

The initial phase of the school fused art and craft, while the next went on to unite art and technology to create prototypes for mass production. By the late 1920s the Bauhaus had a clear visual identity and a reputation for sleek, functional design.

The Nazis closed down the Bauhaus in 1933, unwittingly ensuring its fame. Its ideology and reputation had already reached a wide audience through its periodical *Bauhaus* (1926–31) and its series of books on art and design theory (1925–30). Now the enforced emigration of many of its staff and students carried its ideas around the globe. The Bauhaus ethos of good functional design became one of the major influences of the twentieth century.

Joost Schmidt
Poster for the '1923
Bauhaus' exhibition, 1923
Lithograph, 66.7 x
47.3 cm (26¼ x 18⅝ in.)
Bauhaus-Archiv, Museum
für Gestaltung, Berlin

This poster was designed by Schmidt when he was a Bauhaus student. The exhibition was a success, attracting over 15,000 visitors. The geometric abstraction employed here became a defining characteristic of the Bauhaus.

KEY ARTISTS, ARCHITECTS AND DESIGNERS

Josef Albers (1888–1976), Germany
Walter Gropius (1883–1969), Germany
Vasily Kandinsky (1866–1944), Russia/USSR
Paul Klee (1879–1940), Switzerland
László Moholy-Nagy (1895–1946), Hungary
Oskar Schlemmer (1888–1943), Germany
Joost Schmidt (1893–1948), Germany

KEY FEATURES

Simple, direct, functional
Refinement of line and shape
Geometric abstraction
Use of primary colours
New materials and technologies

MEDIA

Painting, applied arts, design, architecture and graphics

KEY COLLECTIONS

Bauhaus-Archiv, Museum für Gestaltung, Berlin, Germany
Bauhaus University, Weimar, Germany
Busch-Reisinger Museum, Cambridge, MA, USA
Minneapolis Institute of Arts, Minneapolis, MN, USA
Neue Galerie New York, New York, NY, USA
Neue Nationalgalerie, Berlin, Germany
Victoria and Albert Museum, London, UK
Zentrum Paul Klee, Bern, Switzerland

PRECISIONISM
1920s

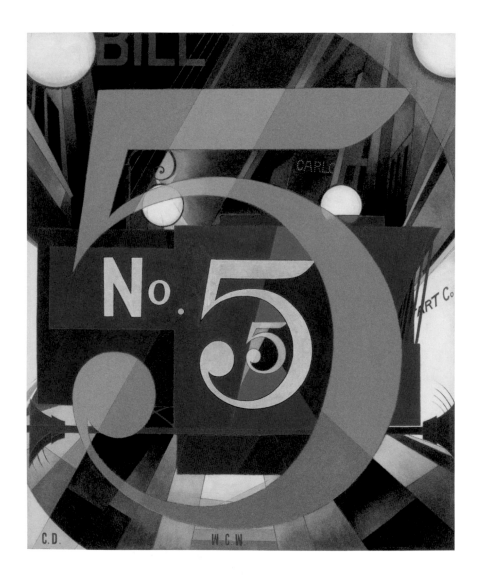

Charles Demuth
I Saw the Figure 5 in Gold,
1928
Oil on composition board,
90.2 x 76.2 cm (35½ x
30 in.)
Metropolitan Museum of
Art, New York

**Perhaps the most famous
Precisionist painting
is this poster-portrait
of Demuth's friend,
the poet William
Carlos Williams, and
an interpretation of
Williams's poem, 'The
Great Figure', which
describes a fire engine
rushing to the scene
of a fire. Demuth has
included his friend's
name and initials in
the painting along
with his own.**

Precisionism, also called Cubist-realism, was a type of American Modernism in the 1920s. Its identifying characteristics are the use of Cubist composition and the machine aesthetics of the Futurists applied to specifically American iconography – the farms, factories and machinery that were an integral part of the American landscape. The name was coined by Charles Sheeler, a painter and photographer, and it aptly describes both his sharp-focus photography and photographic style of painting. In the eyes of many Americans in the 1920s, the machine was an object of glamour and the possibilities of mass-production seemed to herald the liberation of mankind. Sheeler himself was seduced by the American industrial dream, and his paintings of factories and machines endow them with the dignity, monumentality and soaring nobility of cathedrals and ancient monuments.

Precisionism was the most important development in American Modernism of the 1920s. Its influence can be felt in many later generations of both realist and abstract artists. The simplified, abstracted shapes, clean lines and surfaces, and industrial and commercial subject matter anticipate both Pop Art and Minimalism; while the smooth suppression of brushstrokes and respect for careful craftsmanship look forwards to the Super-realism of the 1970s.

KEY ARTISTS
Ralston Crawford (1906–78), USA
Charles Demuth (1883–1935), USA
Georgia O'Keeffe (1887–1986), USA
Charles Sheeler (1883–1965), USA

KEY FEATURES
Simplified, abstracted shapes, clean lines and surfaces
American imagery
Industrial and commercial subject matter

MEDIA
Painting and photography

KEY COLLECTIONS
Butler Institute of American Art, Youngstown, OH, USA
Metropolitan Museum of Art, New York, NY, USA
Museum of Modern Art, New York, NY, USA
Norton Museum of Art, West Palm Beach, FL, USA
Whitney Museum of American Art, New York, NY, USA

ART DECO
c.1920 – c.1940

Art Deco originated in France as a luxurious, highly decorated style.
It then spread quickly throughout the world – most dramatically in
America – becoming more streamlined and modernistic through
the 1930s. Developments in modern art were important, as were
events outside the art world. The exotic sets and costumes of Sergei
Diaghilev's Ballets Russes started a craze for Oriental and Arabian
dress, while the discovery of Tutankhamun's tomb in 1922 sparked
a vogue for Egyptian motifs and shimmering metallic colours.
American jazz culture and dancers, such as Josephine Baker,
captured imaginations too, as did 'primitive' African sculpture.

Art Deco's simplified forms and strong colours were particularly
suited to the graphic arts. Ukranian-born French artist Adolphe
Jean-Marie Mouron, known as Cassandre, was the foremost
poster artist of the era. His elegant posters for various transport
companies brilliantly convey the period's romance with speed, travel
and luxury. Paris-based Polish artist Tamara de Lempicka's bold
patterns, angular forms and metallic colours capture the later,
more streamlined Art Deco look on canvas.

Art Deco was pervasive and popular, finding its way into the
design of everything from jewellery to film sets, from the interiors
of ordinary homes to cinemas, luxury steamliners and hotels. Its
exuberance and fantasy captured the spirit of the 'roaring twenties'
and provided an escape from the realities of the Great Depression
during the thirties.

KEY ARTISTS, ARCHITECTS AND DESIGNERS
Cassandre (Adolphe Jean-Marie Mouron; 1901–68),
 Ukraine–France
Sonia Delaunay (1885–1979), Russia/USSR
Donald Deskey (1894–1989), USA
Tamara de Lempicka (1898–80), Poland
Paul Poiret (1879–1944), France
William Van Alen (1883–1954), USA

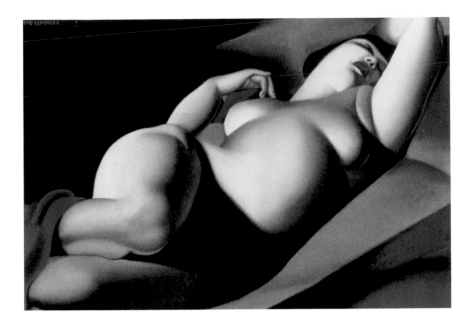

Tamara de Lempicka
La Belle Rafaela, 1929
Oil on canvas, 63.5 ×
91.5 cm (25 × 36 in.)
Private collection

Tamara de Lempicka
captured the sexy
glamour of the roaring
1920s with her distinctive
Art Deco style.

KEY FEATURES

Machine aesthetic

Use of new materials and technologies

Geometric forms

Lavish ornamentation

Glamour

MEDIA

Painting, sculpture, architecture, design and applied arts

KEY COLLECTIONS

Cooper Hewitt Museum, New York, NY, USA

Musée des Arts Décoratifs, Paris, France

Metropolitan Museum of Art, New York, NY, USA

Radio City Music Hall, New York, NY, USA

Victoria and Albert Museum, London, UK

Virginia Museum of Fine Arts, Richmond, VA, USA

HARLEM RENAISSANCE
1920s

The Harlem Renaissance was an African American social, literary and artistic movement that gathered force after the First World War. The 1920s were a time of optimism, pride and excitement for African Americans who hoped that their time for a respectable place in American society had finally arrived. Although its spiritual home was Harlem, New York, it soon blossomed into a national movement that promoted and celebrated the black experience in a variety of art forms.

The leaders of the movement believed that through culture, rather than politics, they could achieve their goal of equal rights and freedoms for black Americans. They reasoned that increased exposure through black arts and literature would help mainstream society see black Americans and their experience as *part of*, rather than *apart from*, the American experience.

Photographer James Van Der Zee, Harlem's premier chronicler of the years 1920 to 1940, provided some of the most enduring, iconic images of the era. Aaron Douglas was the leading artist of the movement with his original style that fused respect for his African ancestral heritage, his experience as an African American and Modernist developments in art. Whether accessing a distant mythical past or nostalgia for a more recent rural one, or celebrating progress and modernity, all the work of the Harlem Renaissance is involved in developing race consciousness and cultural identity for African Americans.

Aaron Douglas
Aspects of Negro Life:
The Negro in an African
Setting, 1934
Oil on canvas, 182.9 x
199.4 cm (72 x 78½ in.)
Schomburg Center
for Research in Black
Culture, The New York
Public Library, New York

Douglas's geometric symbolism harnesses the Precisionists' sharp angles and exuberance for the industrial landscape for his goal of expressing black pride and history in a modern aesthetic.

KEY ARTISTS

Aaron Douglas (1899–1979), USA
Palmer C. Hayden (1893–1973), USA
Loïs Mailou Jones (1905–98), USA
Jacob Lawrence (1917–2000), USA
James Van Der Zee (1886–1983), USA

KEY FEATURES

Images of black folklore, history and everyday life
Images of African ancestry
Search for a modern black identity
Promoting race awareness and pride

MEDIA

Visual art and literature

KEY COLLECTIONS

Art Institute of Chicago, Chicago, IL, USA
Museum of Modern Art, New York, NY, USA
National Gallery of Art, Washington, DC, USA
Schomberg Center for Research in Black Culture, New York,
 NY, USA
Smithsonian American Art Museum, Washington, DC, USA

MEXICAN MURALISM
1920s–30s

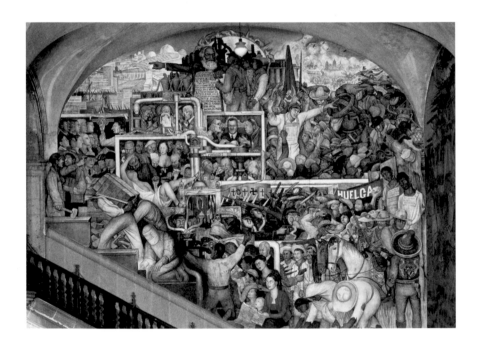

The Mexican Muralists were a state-sponsored, ideologically driven avant-garde of the 1920s and 1930s whose primary goal was to reclaim and recreate a Mexican identity based on the country's precolonial past. Diego Rivera, José Clemente Orozco and David Alfaro Siqueiros – 'Los tres grandes' (The Big Three) – exerted an enormous influence not only in their native Mexico but also internationally, especially in the United States.

The Big Three reinvigorated mural painting by creating a socially and politically committed popular public art based on a fusion of European styles and native traditions. Broadly speaking, their work could be called figurative Social Realism, but each had a distinctive revolutionary style and subject matter. Rivera created figure- and event-packed compositions intended to inspire a sense of pride and proclaim a better future through socialism. Siqueiros used a mixture of realism and fantasy in his bold, turbulent murals to express the raw power of the workers' universal struggle. For his part, Orozco chose to convey the horrible human suffering of the downtrodden in a heartfelt, expressionistic Social Realism.

In addition to the large number of murals they painted in their homeland, The Big Three also painted major murals in the USA during the 1930s. These provided a powerful model for the American Social Realists, who were themselves trying to create an epic national style that was not antimodern.

Diego Rivera
History of Mexico: From the Conquest to the Future, 1929–35
Fresco, south wall
National Palace,
Mexico City

Rivera created figure- and event-packed compositions dealing with both traditional and modern subject matter intended to inspire a sense of pride in his audience's Mexican heritage and proclaim a better future through socialism. He worked in a flat, decorative style with simplified forms, using both stylized figures as well as realistic, identifiable characters to tell his stories.

KEY ARTISTS

José Clemente Orozco (1883–1949), Mexico
Diego Rivera (1886–1957), Mexico
David Alfaro Siqueiros (1896–1974), Mexico

KEY FEATURES

Figurative
Social realism
Heroic
Dynamic
Socially conscious

MEDIA

Mural paintings

KEY COLLECTIONS

Baker-Berry Library, Dartmouth College, Hanover, NH, USA
Centro Médico La Raza, Mexico City, Mexico
Detroit Institute of Arts, Detroit, MI, USA
Escuela Nacional Preparatoria, Mexico City, Mexico
National Palace, Mexico City, Mexico
Pomona College, Claremont, CA, USA

MAGIC REALISM
1920s–50s

Magic Realism describes a style of painting popular from the 1920s to 1950s in the USA and Europe. In general, the works are characterized by a meticulous, almost photographic rendering of realistic-looking scenes endowed with mystery and magic through ambiguous perspectives and strange juxtapositions, largely derived from the Metaphysical paintings of Giorgio de Chirico. Like the Surrealists, Magic Realists used free association to create a sense of wonder in everyday subjects, but they rejected Freudian dream imagery and automatism.

René Magritte is the most widely known of the Magic Realists, with his painstakingly realistic 'fantasies of the commonplace'. His pictures raise questions about the reality of representation, set up oppositions between real space and fictive space and challenge the concept of a painting as a window on the world. His techniques – incongruous juxtapositions, paintings within paintings, combinations of the erotic and the ordinary, and disruptions of scale and perspective – translate everyday objects into images of mystery.

The Magic Realists' strategies, in particular the blending of realistic imagery and magical content, have exerted considerable influence on later artists, such as those associated with Nouveau Réalisme, Neo-Dada, Pop Art and Super-realism.

René Magritte
The Treachery (or Perfidy)
of Images (This is Not a
Pipe), 1929
Oil on canvas, 60.3 x
81.1 x 2.5 cm (23¾ x
32 x 1 in.)
Los Angeles County
Museum of Art, Los
Angeles

Magritte was interested in the relationship between objects, images and language. This celebrated picture depicts a pipe that is not a pipe – because it is a painting of a pipe, a mere representation of reality. Much of Magritte's work draws attention to the role of vision, the ways in which our intellect and emotions condition our perception of reality, and, ultimately, question the reality we see.

KEY ARTISTS

Ivan Albright (1897–1983), USA
Peter Blume (1906–92), USA
Paul Delvaux (1897–1994), Belgium
O. Louis Guglielmi (1906–56), USA
René Magritte (1898–1967), Belgium
Pierre Roy (1880–1950), France
George Tooker (1920–2011), USA

KEY FEATURES

Precise, meticulous
Realistic-looking scenes endowed with mystery and magic
Ambiguous perspectives and strange juxtapositions

MEDIA

Painting

KEY COLLECTIONS

Los Angeles County Museum of Art, Los Angeles, CA, USA
Magritte Museum, Brussels, Belgium
Metropolitan Museum of Art, New York, NY, USA
Museum of Modern Art, New York, NY, USA
Norton Museum of Art, West Palm Beach, FL, USA
Smithsonian American Art Museum, Washington, DC, USA
Tate, London, UK

NEO-ROMANTICISM
1920s–50s

Neo-Romanticism is used to describe two related but distinct
groups of painters: a group in Paris during the 1920s and 1930s;
and a group in England at work between the 1930s and 1950s.

Key figures in Paris included Frenchman Christian Bérard and
Russian émigrés Pavel Tchelitchew and the Berman brothers,
Eugène and Leonid. Their realistically rendered fantastic images
typically show abandoned landscapes with sad, tragic or horrifying
figures, and it is easy to trace the influence of Surrealism, Giorgio
de Chirico's *Pittura Metafisica* and René Magritte's Magic Realism in
their visionary and mysterious scenery.

The English Neo-Romantics consciously drew on native themes and styles in their work. At a time of impending war, they anglicized European Modernism to suit their own needs. Generally speaking, the works they produced are emotionally and symbolically charged, and in them nature is presented as a source of both strangeness and beauty. Objects in the landscapes, whether natural or man-made, are depicted as characters with their own personalities. Elements, be they trees, buildings or even wrecked aircraft, are humanized in this fusion of Surrealist imagery with the English landscape tradition.

Paul Nash
Defence of Albion, 1942
Oil on canvas, 122 x 182.8 cm (48 x 72 in.)
Imperial War Musuem, London

Nash's image of the sinking of a U-boat by bombing recalls the Surrealist interest in the link between animate and inanimate and the battle between machines and nature, in which nature, specifically the English countryside, metaphorically prevails.

KEY ARTISTS

Michael Ayrton (1921–75), UK
Christian Bérard (1902–49), France
Eugène Berman (1899–1972), Russia
Leonid Berman (1896–1976), Russia
Paul Nash (1889–1946), UK
John Piper (1903–92), UK
Graham Sutherland (1903–80), UK
Pavel Tchelitchew (1898–1957), Russia

KEY FEATURES

Brooding and mysterious
Sense of loss and alienation
Realistically rendered
Landscapes

MEDIA

Painting, illustration and book design

KEY COLLECTIONS

Aberdeen Art Gallery, Aberdeen, UK
Fine Arts Museums of San Francisco, San Francisco, CA, USA
Imperial War Museum, London, UK
Museum of Modern Art, New York, NY, USA
National Gallery of Art, Washington, DC, USA
Tate, London, UK

NEUE SACHLICHKEIT
1924–33

20/40 II

Otto Dix
Night-time encounter with a madman, plate 22 of *Der Krieg*, 1924
Etching, 25.5 x 19.3 cm (10 x 7⅝ in.)
Lindenau-Museum, Altenburg

Dix's gruesome depiction of the realities of war in his collection of etchings, *Der Krieg* (The War), were described by art historian G. H. Hamilton as being 'perhaps the most powerful as well as the most unpleasant anti-war statements in modern art'.

The term Neue Sachlichkeit (German: New Objectivity) is used to describe the realistic tendency in German art of the 1920s. As German politics shifted to the right after the First World War, many artists adopted an anti-idealistic, socially engaged realistic style to record and critique the contemporary scene. Käthe Kollwitz, Max Beckmann, Otto Dix and George Grosz worked in different styles, but shared a number of themes: the horrors of war, disgust with German society's social hypocrisy, moral decadence and political corruption; the plight of the overlooked poor; and the rise of Nazism.

Kollwitz is best known for her intense images of the human suffering caused by war and poverty, and Beckmann for his harsh, symbolic portrayals of twisted, tortured figures that lay bare the spiritual cost of man's inhumanity to man. The expressionist angst of Kollwitz and Beckmann turns to bitter cynicism in the hands of Dix and Grosz, whose distorted realism is savagely satirical. The unsparing images presented in Neue Sachlichkeit works record the various faces of evil, past and present, as well as warn of the one to come. The fall of the Weimar Republic and the rise of Nazism put an end to the movement as all of the artists were stripped of official positions and much of their work was confiscated or destroyed.

KEY ARTISTS

Max Beckmann (1884–1950), Germany
Otto Dix (1891–1969), Germany
George Grosz (1893–1959), Germany
Käthe Kollwitz (1867–1945), Germany

KEY FEATURES

Sense of disillusionment, anger, disgust
Satirical and cynical
Desire to express immediate reality without idealizing it

MEDIA

Painting, sculpture and graphics

KEY COLLECTIONS

Fine Arts Museums of San Francisco, San Francisco, CA, USA
Museum Kunstpalast, Düsseldorf, Germany
Museum of Modern Art, New York, NY, USA
Neue Galerie New York, New York, NY, USA
Neue Nationalgalerie, Berlin, Germany
Staatsgalerie, Stuttgart, Germany

SURREALISM

1924–59

Above: Salvador Dalí
Sleep (Le Sommeil), 1937
Oil on canvas, 51 x 78 cm
(10⅛ x 30¾ in.)
Private collection

**Dalí worked in a variety
of media, but common
to all his work is the
ability to make arresting
associations.**

Opposite: Joan Miró
*Head of a Catalan
Peasant*, 1924
Oil and crayon on
canvas, 146 x 114.2 cm
(57½ x 45 in.)
National Gallery of Art,
Washington, DC

**Miró's paintings
brilliantly display
the classic Surrealist
transformation of the real
into the marvellous.**

Surrealism means 'above realism' or 'more than real'. It was launched as a literary and artistic movement in France in 1924 by poet André Breton who defined it as, 'Thought expressed in the absence of any control exerted by reason, and outside all moral and aesthetic considerations.' He, and the many artists who joined him, believed that by liberating the unconscious and reconciling it with the conscious, mankind could be freed from the shackles of logic and reason. They drew on aspects of Dada and the ideas of Austrian psychoanalyst Sigmund Freud, who believed that analysing dreams could help us understand our unconscious minds and release repressed memories and desires. Most Surrealist work – whether the so-called 'organic' Surrealism of Joan Miró or the 'dream' Surrealism of Salvador Dalí – addresses such disquieting states as fear, desire and eroticization.

Automatism was one of the Surrealist methods of creating. An artist draws or paints purposely without thinking, so that the images come straight from his or her unconscious mind. Joan Miró painted his bright biomorphic forms instinctively, declaring: 'As I paint, the picture begins to assert itself under my brush'. Salvador Dalí was another famous Surrealist. His 'hand-painted dream photographs' are realistically rendered, hallucinatory scenes full of unexpected juxtapositions that explore his phobias and his desires. Dalí was a genius of self-promotion. His carefully turned-up and waxed moustache became a trademark of his appearance. Dalí's art, behaviour and appearance became emblematic of Surrealism.

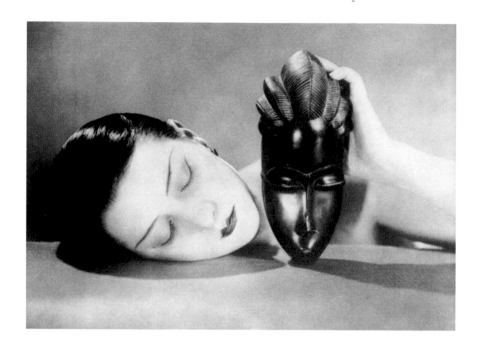

Alberto Giacometti was responsible for the masterpieces of Surrealist sculpture. *Woman with Her Throat Cut* (1932), a bronze construction of a dismembered insect-like female corpse, and *Hands Holding the Void (Invisible Object)* (1934) both portray the body of the female as inhuman and dangerous. *Hands Holding the Void* brings together two ideas important to many of the Surrealists: the idea of the dehumanizing mask (African masks, gas masks, industrial masks), and the idea of the female praying mantis who kills and decapitates the male while copulating. As such, the strange, sad figure in *Hands Holding the Void* could be the 'killer female', representing the fear of women and death and the thrill of dangerous sex. For Breton the piece was 'the emanation of the desire to love and to be loved'.

Man Ray was the first Surrealist photographer. With darkroom manipulation, close-ups and unexpected juxtapositions, photography proved an adept medium for isolating the surreal image present in the world. Photography's dual status as both document and art strengthened the Surrealist claim that the world is full of erotic symbols and surreal encounters.

Surrealism burst onto the international stage during the 1930s with major exhibitions in Brussels, Copenhagen, London, New York and Paris. By the time of his death in 1966, Breton had made

Man Ray
Black and White (Noire et Blanche), 1926
Gelatin silver print, 21.2 x 27.5 cm (8⅜ x 14¾ in.)
Stedelijk Museum, Amsterdam

Man Ray worked publicly, and successfully, in the seemingly incompatible worlds of the Parisian avant-garde and commercial photography. His photographs were published in both specialist and popular periodicals. This portrait of Kiki of Montparnasse originally appeared in *Vogue*.

Surrealism one of the most popular movements of the twentieth century. It had spread to all corners of the globe and affected all disciplines, and its very name had entered everyday usage as a synonym for bizarre.

KEY ARTISTS

Salvador Dalí (1904–89), Spain

Max Ernst (1891–1976), Germany

Alberto Giacometti (1901–66), Switzerland

René Magritte (1898–1967), Belgium

Joan Miró (1893–1983), Spain

Meret Oppenheim (1913–85), Switzerland

Man Ray (1890–1977), USA

KEY FEATURES

Strange juxtapositions, whimsy and dream imagery

Ambiguity

Play between title and image, love of visual and verbal puns

Themes of fear and desire

MEDIA

All

KEY COLLECTIONS

Dalí Theatre-Museum, Figueres, Spain

Fondation Beyeler, Riehen/Basel, Switzerland

Fundació Joan Miró, Barcelona, Spain

Menil Collection, Houston, TX, USA

Neue Nationalgalerie, Berlin, Germany

Museo Nacional Centro de Arte Reina Sofia, Madrid, Spain

Museum of Modern Art, New York, NY, USA

Salvador Dalí Museum, St Petersburg, FL, USA

Solomon R. Guggenheim Museum, New York, NY, USA

Stedelijk Museum, Amsterdam, Netherlands

Tate, London, UK

CONCRETE ART
1930 – c.1960

Dutch artist and theorist Theo van Doesburg, founder of De Stijl, defined Concrete Art in a manifesto in 1930. On the one hand, the manifesto succinctly differentiated Concrete Art from a whole range of new figurative styles (including Social Realism and Surrealism), and, on the other, certain forms of abstract art, such as expressive abstraction and work abstracted from nature, or abstracted nature (including Cubism, Futurism and Purism).

In contrast, there was to be nothing sentimental, nationalistic or romantic in Concrete Art. Its roots lay in Suprematism, Constructivism and De Stijl. Its aim was to be universally valid and clear, the product of the conscious, rational mind of an artist who has no use for illusionism or symbolism. The art was to be *concrete*: an entity in itself, not a vehicle for spiritual or political ideas. In practice, the term Concrete Art became a synonym for geometrical abstraction in both painting and sculpture. In the art there is an emphasis on real materials and real space, and a love of grids, geometric shapes and smooth surfaces. The artists often took as their starting points scientific concepts or mathematical formulae. The work is cool, calculated, impersonal and precise.

Max Bill
*Rhythm in Four
Squares*, 1943
Oil on canvas, 30 x
120 cm (11¾ x 47¼ in.)
Kunsthaus Zürich, Zurich

Bill's work is characterized by attention to detail, clarity and geometric simplicity. The emphasis of his rigorously composed painting is on real materials and real space.

KEY ARTISTS
Max Bill (1908–94), Switzerland
César Domela (1900–92), Netherlands
Jean Hélion (1904–87), France
Barbara Hepworth (1903–75), UK
Ben Nicholson (1894–1982), UK
Ad Reinhardt (1913–67), USA

KEY FEATURES
Geometric abstraction
Cool execution
Attention to detail
Clarity

MEDIA
Painting and sculpture

KEY COLLECTIONS
Hirshhorn Museum and Sculpture Garden, Washington, DC, USA
Museum Haus Konstruktiv, Zurich, Switzerland
Museum of Concrete Art, Ingolstadt, Germany
Museum of Modern Art, Rio de Janiero, Brazil
Tate St Ives, St Ives, UK

AMERICAN SCENE
c.1930–c.1940

Two defining events of the 1930s, the Great Depression and the rise of Fascism in Europe, prompted many American artists to turn away from abstraction and adopt realistic styles of painting to document the social environment in America. Along with the Social Realists, the American Scene painters (also called American Gothic painters and Regionalists) produced images of America that ranged from gloomy isolation to the splendour of a new rural Eden.

Scenes of rural and small-town vernacular architecture by Charles Burchfield and desolate images of urban and suburban America by Edward Hopper convey a strong sense of loneliness and despair. The same subject matter was given a more optimistic, nostalgic spin in the hands of Regionalists such as Thomas Hart Benton and Grant Wood. Benton painted public murals portraying the idealized social history of the people of the Midwest in a muscular figuration reminiscent of Michelangelo. Grant Wood created the most famous Regionalist painting, *American Gothic* (1930), which has given its name to the gaunter, more awkward aspect of American Scene painting. His rendering of the stoical, puritanical Iowan farmers supplied Depression America with an image that celebrated the endurance of hard-working Middle Americans.

Grant Wood
American Gothic, 1930
Oil on beaverboard,
78 x 63.5 cm
(30¾ x 25 in.)
Art Institute of Chicago,
Chicago

Wood's highly realistic style was derived from his study of sixteenth-century Flemish painting. Enormously popular at the time, the painting has remained in the public's psyche, partly due to the numerous variations (replacing the farmers with anyone from yuppies to presidential couples) to which it has been subjected by advertisers and cartoonists. The painting has become a national icon and the house in the background is now a tourist attraction in Eldon, Iowa.

KEY ARTISTS

Thomas Hart Benton (1889–1975), USA
Charles Burchfield (1893–1967), USA
Edward Hopper (1882–1967), USA
Grant Wood (1892–1942), USA

KEY FEATURES

Realism
Nostalgic, heroic
Ordinary, anonymous subjects
American imagery

MEDIA

Paintings, prints and murals

KEY COLLECTIONS

Art Institute of Chicago, Chicago, IL, USA
Burchfield Penney Art Center, Buffalo, NY, USA
Cincinnati Art Museum, Cincinnati, OH, USA
Smithsonian American Art Museum, Washington, DC, USA
Whitney Museum of American Art, New York, NY, USA

SOCIAL REALISM
c.1930 – c.1940

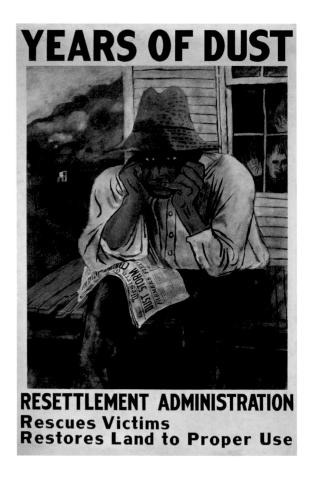

After the Depression and the rise of Fascism in Europe, left-wing artists in 1930s America tried to distance themselves from the perceived decadence of Europe and European abstraction. As they searched for a unique 'American' art that defined America and differentiated it from Europe, they looked to the Ashcan School and the Mexican Muralists for examples of popular figurative art with social content. Although often depicting similar subject matter, the

harsh gaze and gritty realism of the Social Realists separates their work from both the heroic peasants of Soviet Socialist Realism and the idealized vision of America's agrarian past of the Regionalists (see American Scene).

Also often called 'Urban Realists' – Ben Shahn, Reginald Marsh, Alice Neel, William Gropper, Isabel Bishop and the brothers Moses and Raphael Soyer – documented the human cost of the political and economic tragedies of the day, with a characteristic blend of reportage and biting social commentary. Shahn was both a photographer and a painter and, like many of his colleagues, often depicted victims of miscarriages of justice. With other artists and photographers of the 1930s, Shahn worked for the Farm Security Administration, recording the conditions of the rural poor in order to agitate for Federal assistance for them.

Ben Shahn
Years of Dust:
Resettlement
Administration Rescues
Victims, Restores Land
to Proper Use, 1936
Lithograph, 96.2 x 63.5
cm (37⅞ x 25 in.)
Library of Congress,
Washington, DC

Shahn's work for the Farm Security Administration and Resettlement Agency exposed the living conditions of the rural poor during the Great Depression. This poster promoted government relief programmes to help people get back on their feet.

KEY ARTISTS
Isabel Bishop (1902–88), USA
William Gropper (1897–1977), USA
Reginald Marsh (1898–1954), USA
Alice Neel (1900–84), USA
Ben Shahn (1898–1969), USA
Moses Soyer (1899–1974), USA
Raphael Soyer (1899–1987), USA

KEY FEATURES
Figurative and narrative
Social commitment
Images of the poor and the oppressed
Urban realism

MEDIA
Painting, graphics and photography

KEY COLLECTIONS
Art Institute of Chicago, Chicago, IL, USA
Butler Institute of American Art, Youngstown, OH, USA
Metropolitan Museum of Art, New York, NY, USA
National Museum of Women in the Arts, Washington, DC, USA
Phillips Collection, Washington, DC, USA
Smithsonian Museum of American Art, Washington, DC, USA
Springfield Museum of Art, Springfield, OH, USA
Whitney Museum of American Art, New York, NY, USA

SOCIALIST REALISM
1934 – c.1985

Socialist Realism was declared the official artistic style of the
Soviet Union in 1934. All artists had to join the state-controlled
Union of Soviet Artists and produce work in the accepted mode.
The three guiding principles of Socialist Realism were party loyalty,
presentation of correct ideology and accessibility. Realism, more
easily understood by the masses, was the style of choice, but not a
critical realism (as in the work of Social Realists elsewhere), but an
inspirational and educational one. Socialist Realism was to glorify the
state and celebrate the superiority of the new classless society being
built by the Soviets. Both subject matter and its representation were
carefully monitored.

Artistic merit was determined by the degree to which a work contributed to the building of socialism; work that did not was banned. Paintings approved by the state typically showed men and women at work or playing sports, political assemblies, political leaders and the achievements of Soviet technology. These are portrayed in a naturalistic idealized fashion, in which the people are young, muscular, happy members of a progressive, classless society, and its leaders are heroes. Socialist Realism remained the house style of the Soviet Union and its satellites until Mikhail Gorbachev's *glasnost* (openness) campaign in the mid-1980s.

Isaak Brodsky
Assembly of the
Revolutionary Military
Council of the USSR,
Chaired by Kliment
Voroshilov, 1929
Oil on canvas, 95.5 x
129.5 cm (37½ x 51 in.)
Private collection

Brodsky was a prominent Socialist Realist, known for his paintings of political events and leaders. His conventional, academic figurative style was well suited to the needs of the state.

KEY ARTISTS

Isaak Brodsky (1884–1939), Russia/USSR
Alexander Deineka (1899–1969), Russia/USSR
Alexander Gerasimov (1881–1963), Russia/USSR
Sergei Gerasimov (1885–1964), Russia/USSR
Alexander Laktionov (1910–72), Russia/USSR
Vera Mukhina (1889–1953), Russia/USSR
Boris Vladimirski (1878–1950), Russia/USSR

KEY FEATURES

Scenes of collective farms and industrialized cities
Monumental in scale
Air of heroic optimism
Idealized naturalism

MEDIA

All

KEY COLLECTIONS

Astrakhan State Art Gallery, Astrakhan, Russia
Russian Academy of Fine Arts Museum, St Petersburg, Russia
The State Historical Museum, Moscow, Russia
The State Russian Museum, St Petersburg, Russia
The State Tretyakov Gallery, Moscow, Russia

A NEW DISORDER
1945–65

-

**It is true that only one thing has ever been
asked of our generation – that it should be able to
cope with despair**

-

Albert Camus

1944

ORGANIC ABSTRACTION
1940s–50s

Organic Abstraction is the name given to the use of rounded abstract forms based on those found in nature. Also called Biomorphic Abstraction, it was a striking feature of the work of many different artists, particularly during the 1940s and 1950s, such as Jean (Hans) Arp, Joan Miró, Barbara Hepworth and Henry Moore. The shapes of their sculptures show obvious affinities with natural forms, such as bones, shells and pebbles. Their work was very popular, and appealed both to other artists and a whole generation of furniture designers, especially in the USA, Scandinavia and Italy.

Innovative technological developments (such as new bending techniques and new laminates of various materials) allowed prominent furniture designers in the USA, such as Charles and Ray

Eames and Isamu Noguchi, to create increasingly organic designs. Combined with the general perception that rounded shapes were more comfortable, organic furniture appeared both cutting edge and welcoming.

In Italy, design with a strongly organic feel played a major role in post-war reconstruction. Fusing aspects of American design, Surrealism and the sculptures of Moore and Arp, a distinctive organic aesthetic appeared throughout Italy, from industrial design – cars, typewriters and Vespas – to interior design and furniture. Scandinavia was another home of Organic Abstraction in the 1940s and 1950s, with architect-designers such as Alvar Aalto fusing Organic Abstraction with Modernist refinement in buildings, interiors, furniture and swimming pools.

Henry Moore,
Reclining Figure, 1936
Elm wood, 105.4 x 227.3 x 89.2 cm (36½ x 89½ x 35⅛ in.)
The Hepworth Wakefield, Wakefield

In 1937 Moore recorded his belief that 'there are universal shapes to which everybody is subconsciously conditioned and to which they can respond if their conscious control does not shut them off'. The rounded, free-flowing shapes of his sculptures were admired as 'drawings in space' by other artists and designers.

KEY ARTISTS AND DESIGNERS

Alvar Aalto (1898–1976), Finland
Jean Arp (1886–1966), France–Germany
Achille Castiglioni (1918–2002), Italy
Charles Eames (1907–78), USA
Ray Eames (1912–88), USA
Barbara Hepworth (1903–75), UK
Arne Jacobsen (1902–71), Denmark
Joan Miró (1893–1983), Spain
Henry Moore (1898–1986), UK
Isamu Noguchi (1904-88), USA

KEY FEATURES

Rounded abstract forms
Nature as a source of inspiration

MEDIA

Painting, sculpture, furniture, architecture and industrial design

KEY COLLECTIONS

Designmuseum Danmark, Copenhagen, Denmark
Henry Moore Studios & Gardens, Perry Green, UK
Museo del Design 1880–1980, Milan, Italy
Museum of Modern Art, New York, NY, USA
Noguchi Museum, Long Island City, NY, USA
Tate St Ives, St Ives, UK
The Hepworth Wakefield, Wakefield, UK
Vitra Design Museum, Weil am Rhein, Germany

EXISTENTIAL ART
c.1945 – c.1960

Existentialism was the most popular philosophy of post-war Europe. It posited that man is alone in the world without any pre-existing moral or religious systems to support and guide him. On the one hand he is forced to a realization of his solitariness, of the futility and absurdity of existence; on the other he has the freedom to define himself, to reinvent himself with every action. Such themes captured the mood of the immediate post-war years and exerted

a powerful influence on artistic and literary developments in the 1950s. Writers such as Jean-Paul Sartre, Albert Camus and Samuel Beckett saw the artist as one who is continually searching for new forms of expression, as constantly enacting man's Existential predicament.

Jean Fautrier and Germaine Richier were praised for their 'authenticity' (a key notion of Existential thought), and their paintings and sculptures were seen as either hopeful or pessimistic – as images of the horrors of war or of the power of man to transcend it. For many, former Surrealist Alberto Giacometti was the archetypal Existentialist artist. His obsessive reworking of the same subject and his fragile figures lost in wide-open spaces expressed man's isolation and struggle, and the continual need to return to the beginning and start again. The theatricality, violence and claustrophobia of Francis Bacon's paintings and the brooding atmosphere of Lucian Freud's hyper-realist portraits of the 1940s led them to be described as Existentialist artists as well.

Jean Fautrier
Hostage, No. 24, 1945
Mixed media on paper laid down on canvas, 35 x 27 cm (13¾ x 10½ in.)
Private collection

Fautrier's most famous series of paintings and sculptures, *Hostages*, was made while he was hiding out at a mental asylum on the outskirts of Paris during the war, where he could hear the screams of prisoners being tortured and executed by the Nazis in the surrounding forest. This harrowing experience is reflected in the works themselves. His manipulation of his materials, creating layered and scored surfaces, lend the appearance of mutilated flesh to the truncated body parts. Although he produced pictures of such explicit violence, Fautrier stopped short of completely obliterating the human figure.

KEY ARTISTS

Francis Bacon (1909–92), UK
Jean Fautrier (1898–1964), France
Lucian Freud (1922–2011), UK
Alberto Giacometti (1901–66), Switzerland
Germaine Richier (1904–59), France

KEY FEATURES

Themes of authenticity, angst, alienation, absurdity, disgust, transformation, metamorphosis, anxiety and freedom

MEDIA

Painting, sculpture and literature

KEY COLLECTIONS

Centre Georges Pompidou, Paris, France
Fondation Beyeler, Riehen/Basel, Switzerland
Louisiana Museum of Art, Humlebaek, Denmark
Moderna Museet, Stockholm, Sweden
Stedelijk Museum, Amsterdam, Netherlands
Tate, London, UK

OUTSIDER ART
c.1945–

Outsider Art describes art created by untrained artists. Art Brut
(raw art), Visionary Art, Intuitive Art, Folk Art, Self-taught Art
and Grassroots Art are other terms used to describe art made by
those outside the art system. Some of the most impressive works of
Outsider Art are monumental structures built over many years. One
is the bizarre Palais Idéal (Ideal Palace) in Hauterives, France, begun
in 1879 by French postman Le Facteur Cheval. The eccentric Watts

Towers (1921–54) in Los Angeles, California, by Italian construction worker Simon Rodia, is another celebrated monument. Both Cheval and Rodia laboured on their buildings for thirty-three years. The extraordinary Rock Garden of Chandigarh, a 25-acre environment by Indian roads inspector Nek Chand, is another.

Outsider Artists are admired for their sincerity and perseverance and present the seductive model of the artist as one who is compelled to create – the notion of art-making as necessity, not choice. Growing public recognition and appreciation for Outsider Art has brought it into the mainstream. One of the most prominent examples is that of the Reverend Howard Finster, whose work became familiar to millions through his album covers for the bands Talking Heads (*Little Creatures*, 1985) and R.E.M. (*Reckoning*, 1988). Outsider Art has entered major museums and its monuments and environments are being protected.

Adolf Wölfli
West-European Coast or Atlantic Ocean, 1911
Coloured pencils on newspaper, 99.5 x 71.1 cm (40 x 28 in)
Adolf Wölfli Foundation, Kuntsmuseum Bern, Bern

For around thirty years, in his cell in an asylum, schizophrenic Wölfli worked on his enormous autobiography. In it he combines the real and the imaginary into a fantastic voyage told through elaborately detailed text and illustrations.

KEY ARTISTS
Nek Chand (1924–2015), India
Le Facteur (Ferdinand) Cheval (1836–1924), France
Howard Finster (1916–2001), USA
William Hawkins (1895–1990), USA
Simon Rodia (c.1879–1965), Italy–USA
Bill Traylor (1854–1949), USA
Alfred Wallis (1855–1942), UK
Adolf Wölfli (1864–1930), Switzerland

KEY FEATURES
Naïve quality, direct expression, rawness

MEDIA
Painting, sculpture, installations and environments

KEY COLLECTIONS
Adolf Wölfli Foundation, Kunstmuseum Bern, Bern, Switzerland
Collection de l'Art Brut, Lausanne, Switzerland
High Museum of Art, Atlanta, GA, USA
Milwaukee Art Museum, Milwaukee, WI, USA
Museum of Naïve and Marginal Art, Jagodina, Serbia
Smithsonian American Art Museum, Washington, DC, USA
The Whitworth, The University of Manchester, Manchester, UK

ART INFORMEL
c.1945–c.1960

Art Informel (French: art without form) was one of the names used in Europe for the type of gestural abstract painting that dominated the international art world from the mid-1940s until the late 1950s. Others included Lyrical Abstraction, Matter Painting and Tachism (from the French *tâche*: blot, stain). Influenced by the Existentialism of the era, Art Informel artists were celebrated for their individuality, authenticity, spontaneity and emotional and physical engagement in the process of creating images whose only subject appeared to be the artist's 'inner being'. Lyrical Abstraction drew attention to the physical action of painting by artists such as Georges Mathieu, Hans Hartung and Wols; Matter Painting stressed the evocative powers of the materials used by artists including Jean Fautrier and Alberto Burri; while Tachism focused on the expressive gesture of the artist's mark as those in the works by Patrick Heron and Henri Michaux.

The sheer popularity of expressive gestural abstraction in the 1950s led to Abstract Expressionism and Art Informel becoming a kind of international style of painting in the post-war period. However, by the late 1950s there appeared a new generation of artists (see Neo-Dada, Nouveaux Réalisme and Pop Art) to question its stature and dominance.

Wols
The Blue Phantom, 1951
Oil on canvas, 73 x
60 cm (28¾ x 23⅝ in.)
Museum Ludwig, Cologne

Wols was a major source of inspiration for artists and writers alike, such as Jean-Paul Sartre, who wrote in 1963, long after the artist's death, that: 'Wols, human and Martian together, applies himself to seeing the earth with inhuman eyes: it is, he thinks, the only way of universalizing our experience.'

KEY ARTISTS
Alberto Burri (1915–95), Italy
Hans Hartung (1904–89), Germany–France
Patrick Heron (1920–99), UK
Georges Mathieu (1921–2012), France
Henri Michaux (1899–1984), Belgium–France
Wols (Alfred Otto Wolfgang Schulze; 1913–51), Germany

KEY FEATURES
Gestural, expressive, spontaneous, raw, splotches of colour
Unusual materials, mixed media

MEDIA
Painting

KEY COLLECTIONS
Centre Georges Pompidou, Paris, France
Hamburger Kunsthalle, Hamburg, Germany
Museo del Novecento, Milan, Italy
Solomon R. Guggenheim Museum, New York, NY, USA
Tate, London, UK

ABSTRACT EXPRESSIONISM
c.1945–c.1960

Abstract Expressionism refers to paintings by a group of US-based artists who were prominent during the 1940s and 1950s, including Willem de Kooning, Franz Kline, Robert Motherwell, Barnett Newman, Jackson Pollock, Mark Rothko and Clyfford Still. Other terms used included Action Painting and Colour Field Painting, each describing a different aspect of Abstract Expressionism. Action Painting, for instance, drew attention to the assertive bodily engagement of the artist in Pollock's drip paintings, de Kooning's violent brushwork and Kline's bold, monumental black-and-white forms. It also conveyed the artists' commitment to the act of creation in the face of continual choice, tying their work to the prevailing climate of the immediate post-war era, in which a painting was not merely an object, but a record of the Existential struggle with freedom, responsibility and self-definition. Colour Field was

Mark Rothko
No.27 (Light Band)
[White Band], 1954
Oil on canvas, 205.7 x
220 cm (81 x 86⅝ in.)
Private collection

Rothko always insisted his paintings should be hung close together, near ground level, in order to engage the viewer as directly as possible. 'I'm not an abstract artist,' he said, 'I'm interested only in expressing human emotions.'

used to refer to work by Rothko, Still, Newman and others, which employed unified blocks of intense colour to invite contemplation.

While many of their works are abstract, the artists insisted that they were not devoid of subject matter. Like the Expressionists, they felt that the true subject of art was man's inner emotions, his turmoil, and to this end they exploited the fundamental aspects of the painting process – gesture, colour, form and texture – for their expressive and symbolic potential. What the artists ultimately sought was subjective and emotional; it was 'basic human emotions' (Rothko); 'only myself, not nature' (Still); 'to express my feelings rather than illustrate them' (Pollock); 'a search for the hidden meaning of life' (Newman); 'to put some order into ourselves' (de Kooning); 'to wed oneself to the universe' (Motherwell). With their European contemporaries (see Existential Art and Art Informel), they shared a romantic vision of the artist as alienated from mainstream society, a figure morally compelled to create a new type of art that might confront an irrational, absurd world.

The best-known Action painter is Jackson Pollock. Captured at work on film and in photographs for *Life* magazine in 1949, 'Jack the Dripper' became the archetype of the new artist. It was his radical innovation, in the 1950s, to lay his canvases on the floor, dripping paint onto them straight from the can or with a stick or trowel, creating labyrinthine images he described as 'energy and motion made visible'. De Kooning is well known for his commitment to the human figure, specifically the American pin-up girl familiar from advertising hoardings all over the country. He became notorious for his *Woman* series in the 1950s, in which the expressive violence

Jackson Pollock
Autumn Rhythm, 1950
Oil on canvas, 266.7 x 525.8 cm (105 x 207 in.)
Metropolitan Museum of Art, New York

Far from being slapdash, Pollock's drip paintings are tightly disciplined and show an assured sense of harmony and rhythm, reminding some critics of his training under Thomas Hart Benton (see American Scene). Pollock's Jungian analysis also fed into his paintings, in which there are frequent references to aspects of myth: altars, priests, totems and shamans.

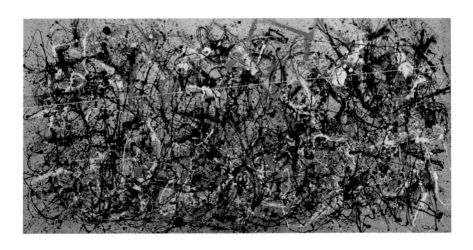

of his brushstrokes created a monstrous but memorable image of sexual anxiety. Mark Rothko was the most religious Abstract Expressionist. His mature paintings of stacked horizontal fields of intense colours that seem to float and shimmer are illuminated with an ethereal glow.

Abstract Expressionism received international recognition and acclaim by the late 1950s. By this time, however, it was being viewed sceptically by a new generation of artists weary of the seemingly formulaic heroic, alienated angst of their predecessors (see Neo-Dada, Nouveau Réalisme and Pop Art).

Willem de Kooning
Seated Woman, 1952.
Graphite, charcoal, and pastel on paper, 46 x 51 cm (20 x 18 in.)
Private collection, Boston, MA

De Kooning became notorious for his *Woman* series of paintings. Discussing the series in 1964, he said: 'I wanted them to be funny, so I made them look satiric and monstrous, like sibyls ... I find I can paint pretty young girls, yet when it is finished I always find they are not there, only their mothers.'

KEY ARTISTS

Willem de Kooning (1904–97), Netherlands–USA
Franz Kline (1910–62), USA
Robert Motherwell (1915–91), USA
Barnett Newman (1905–70), USA
Jackson Pollock (1912–56), USA
Mark Rothko (1903–70), USA
Clyfford Still (1904–80), USA

KEY FEATURES

Abstract, gestural, expressive and emotional
Large fields of colour

MEDIA

Painting

KEY COLLECTIONS

Clyfford Still Museum, Denver, CO, USA
Kawamura Memorial DIC Museum of Art, Sakura, Japan
Museum of Contemporary Art, Los Angeles, CA, USA
Museum of Modern Art, New York, NY, USA
National Gallery of Art, Canberra, Australia
National Gallery of Art, Washington, DC, USA
Rothko Chapel, Houston, TX, USA
Tate, London, UK
Whitney Museum of American Art, New York, NY, USA

CoBrA
1948–51

A NEW
DISORDER

CoBrA was a collective of primarily northern European artists who joined together from 1948 to 1951 to promote their vision of a new expressionist art for the people. The name is derived from the first letters of their hometowns – Copenhagen, Brussels and Amsterdam.

In the climate of despair after the end of the Second World War, this group of young artists demanded an art of immediacy that could convey both the inhumanity of man and the hope for a better future. In their drive for complete freedom of expression, CoBrA artists drew inspiration from a number of sources. In prehistoric art, primitive art, folk art, graffiti, Norse mythology, children's art and the art of the insane, they found a lost innocence and confirmation of man's primordial need to express his desires, whether beautiful or violent, celebratory or cathartic.

By the 1950s, with ongoing wars and the development of the Cold War, the utopian optimism of the group was difficult to sustain. The group officially disbanded in 1951, but many of the artists continued to paint in a CoBrA-esque manner and to support and participate in revolutionary ventures in life and art.

Karel Appel
Questioning Children,
1949
Mixed media, 87.3 x
59.8 cm (34⅜ x 24 in.)
Tate, London

Appel's violently coloured works on the theme of questioning children provoked an uproar in Amsterdam in 1949. A mural painted in the city hall canteen was wallpapered over after complaints from staff that they were unable to eat in its presence.

KEY ARTISTS
Pierre Alechinsky (b.1927), Belgium
Karel Appel (1921–2006), Netherlands
Constant (Constant Anton Nieuwenhuys; 1920–2005), Netherlands
Corneille (Cornelis Guillaume van Beverloo; 1922–2010), Netherlands
Asger Jorn (1914–73), Denmark

KEY FEATURES
Strong primary colours and expressive brushstrokes

MEDIA
Painting, assemblage and graphics

KEY COLLECTIONS
Centre Georges Pompidou, Paris, France
Cobra Museum for Modern Art, Amstelveen, Netherlands
Louisiana Museum of Art, Humlebaek, Denmark
Museum Jorn, Silkeborg, Denmark
Solomon R. Guggenheim Museum, New York, NY, USA
Stedelijk Museum, Amsterdam, Netherlands

BEAT ART
1948 – c.1965

The Beat Generation encompassed a variety of avant-garde writers, visual artists and filmmakers around the USA in the 1950s. What they shared was contempt for conformist, materialist culture and a refusal to ignore the dark side of American life – its violence, corruption, censorship, racism and moral hypocrisy. Sometimes called American Existentialists, the Beat Generation felt alienated from the mainstream and wanted to create their own counter-culture. Drugs, jazz, nightlife, Zen Buddhism and the occult all went into the creation of Beat culture.

Contrary to the nostalgic view of the 1950s as a time of conformity and bliss, Beat Art portrays the 'American way of life' with all its hopes, aspirations and failures. Wallace Berman's collages made with a photocopier present montages of popular culture, the commonplace and the mystical, while Jess's series of *Tricky Cad* collages, made from cut-up Dick Tracy comic strips, present a vision of a world gone mad, of which even the super-sleuth himself cannot make sense.

Beat works had been absorbed into the mainstream by the 1960s, with Beatniks featuring in television shows and popular magazines. The influence of the Beat Generation survived, however, its subversive nonconformity continuing to inspire successive generations of youth and artists.

Jess
Tricky Cad – Case V, 1958
Newspaper, cellulose acetate film, black tape, fabric and paper on paperboard, 33.7 x 63.4 cm (13¼ x 25 in.)
Private collection

Jess's comic-book collages, which play on the name of fictional private detective Dick Tracy, present a confused, tense world in which characters cannot communicate and comment obliquely on the arms race, the McCarthy hearings and political corruption.

KEY ARTISTS
Wallace Berman (1926–76), USA
Jay DeFeo (1929–89), USA
Robert Frank (b.1924), USA
Jess (Burgess Franklin Collins; 1923–2004), USA
Larry Rivers (1923–2002), USA

KEY FEATURES

Images of popular culture, mysticism

Montages

Element of performance

MEDIA

Painting, collage, sculpture, assemblage, photography and film

KEY COLLECTIONS

Hirshhorn Museum and Sculpture Garden, Washington, DC, USA

J. Paul Getty Museum, Los Angeles, CA, USA

Kemper Museum of Contemporary Art, Kansas City, MO, USA

Museum of Modern Art, New York, NY, USA

Norton Simon Museum, Pasadena, CA, USA

Whitney Museum of American Art, New York, NY, USA

NEO-DADA
c.1953 – c.1965

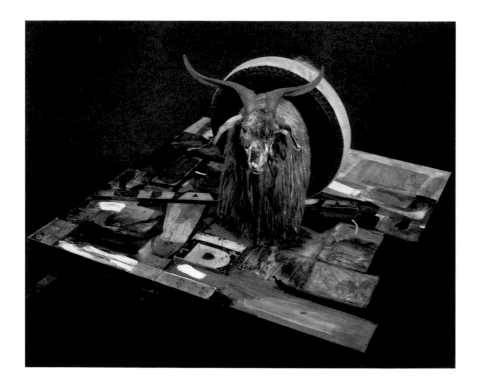

Neo-Dada ('neo' meaning new, young or revived) describes a group of young American experimental artists, whose work was attracting fierce controversy in the mid to late 1950s and 1960s. A revival of interest in Dada at the time led to comparisons with the earlier movement. For artists such as Robert Rauschenberg, Jasper Johns and Larry Rivers, art was to be expansive and inclusive, appropriating non-art materials, embracing ordinary reality and celebrating popular culture. They rejected the alienation and individualism associated with the Abstract Expressionists in favour of a socializing art that emphasized community and the environment.

Robert Rauschenberg
Monogram, 1955-59,
Combine: oil, paper,
printed paper, printed
reproductions, metal,
wood, rubber shoe heel
and tennis ball on canvas,
with oil on Angora goat
and rubber tire, on wood
platform mounted on four
casters, 107 x 161 x 164
cm (42 x 63¼ x 64½ in.)
Moderna Museet,
Stockholm

**Rauschenberg was a
protean, inventive figure,
whose experiments
with painting, objects,
performance and sound
inspired many of his
contemporaries.**

Key Neo-Dada works include Rivers's *Washington Crossing the Delaware* (1953), Rauschenberg's 'Combines' (1954–64) and Johns's flags, targets and numbers. With its Abstract Expressionist-like handling and all-over composition 'contaminated' by unfashionable history painting and figuration, Rivers's reworking of a famous nineteenth-century painting was seen as irreverently taking on both past and present masters. The real-life quality of Johns's flags – a familiar object seen afresh – caused people to query the works' status: was it a flag or a painting? Likewise, Rauschenberg's innovations questioned and stretched the boundaries of art. The influence of the Neo-Dadaists on later art, such as Pop Art, Conceptual Art, Minimalism and Performance, is considerable.

KEY ARTISTS

Lee Bontecou (b.1931), USA
John Chamberlain (1927–2011), USA
Jim Dine (b.1935), USA
Jasper Johns (b.1930), USA
Robert Rauschenberg (1925–2008), USA
Larry Rivers (1923–2002), USA

KEY FEATURES

Mix of materials, use of unusual materials
Irreverence, wit and humour
American imagery
Expressionist brushwork

MEDIA

Painting, assemblage, combines, sculpture and performance

KEY COLLECTIONS

Centre Georges Pompidou, Paris, France
Moderna Museet, Stockholm, Sweden
Museum of Modern Art, New York, NY, USA
Stedelijk Museum, Amsterdam, Netherlands
Tate, London, UK
Whitney Museum of American Art, New York, NY, USA

KINETIC ART
1955 –

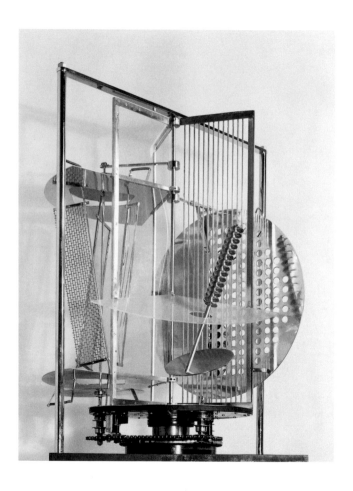

Kinetic Art is art that moves, or appears to move. Numerous artists began to use movement in art during the 1950s, and Kinetic Art became a commonly used classification. The defining exhibition was 'Le Mouvement' held at Galerie Denise René, Paris, in 1955, which included works by historical predecessors Marcel Duchamp and Alexander Calder alongside contemporary artists.

The variety in Kinetic Art is very marked, from slowly moving hypnotic works by Pol Bury, to gracefully swaying outdoor sculptures by George Rickey, cybernetic works by Nicolas Schöffer and telemagnetic sculptures of objects suspended in air by Takis. But perhaps the best-loved body of work is that of Jean Tinguely. In the late 1950s, he became a sensation with his 'meta-matics' – drawing machines that make abstract art – a witty take on the high seriousness and originality associated with the prevailing generation of abstractionists (see Art Informel and Abstract Expressionism). Fountains that sprayed abstract designs followed, as did weird and wacky junk machines and self-destructing machines, such as *Homage to New York*, which performed and destroyed itself on 17 March 1960 at the Museum of Modern Art in New York, an event which Robert Rauschenberg (see Neo-Dada) described as being 'as real, as interesting, as complicated, as vulnerable, as loving as life itself'.

László Moholy-Nagy
Light Prop for an Electric Stage (Light-Space Modulator), 1930
Kinetic sculpture of steel, plastic, wood and other materials with electric motor, 151.1 x 69.9 x 69.9 cm (59½ x 27½ x 27½ in.)
Busch-Reisinger Museum, Harvard Art Museums, Cambridge

Moholy-Nagy's extraordinary *Light-Space Modulator* is an electronically powered rotating sculpture of metal, glass and light beams, which transforms its surrounding space through the play of light reflecting and deflecting off moving elements of different shapes and materials.

KEY ARTISTS
Pol Bury (1922–2005), Belgium
Alexander Calder (1898–1976), USA
László Moholy-Nagy (1895–1946), Hungary–USA
George Rickey (1907–2002), USA
Nicolas Schöffer (1912–92), Hungary–France
Jesús Rafael Soto (1923–2005), Venezuela
Takis (b.1925), Greece
Jean Tinguely (1925–91), Switzerland

KEY FEATURES
Movement

MEDIA
Sculpture and assemblage

KEY COLLECTIONS
Harvard Art Museums, Cambridge, MA, USA
Centre Georges Pompidou, Paris, France
Jesús Soto Museum of Modern Art, Cuidad Bolivar, Venezuela
Museum Jean Tinguely, Basel, Switzerland
Museum of Modern Art, New York, NY, USA
Tate, London, UK
Whitney Museum of American Art, New York, NY, USA

POP ART
1956 – c.1970

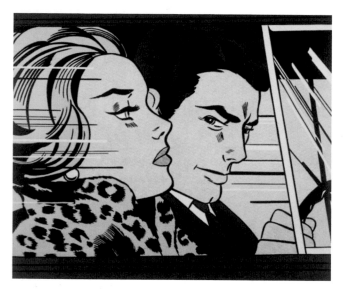

Roy Lichtenstein
In the Car, 1963
Oil and magna on canvas,
172.7 x 203.2 cm
(68 x 80 in.)
Private collection

**Lichtenstein painted
comic-strip frames,
imitating their cheap
printing techniques by
hand. The banality of
the image, blown up
onto canvas, takes on
a sense of allegory and
monumentality. It is both
a parody and a question:
what sort of pictures
do we take seriously
and why?**

The term 'Pop' first appeared in print in an article by English
critic Lawrence Alloway in 1958, but the new interest in popular
culture, and the attempt to make art out of it, was a feature of
the Independent Group in London from the early 1950s. Richard
Hamilton, Eduardo Paolozzi and others discussed the growing
mass culture of movies, advertising, science fiction, consumerism,
media and communications, product design and new technologies
originating in America, but now spreading throughout the west.
They were particularly fascinated by advertising, and graphic and
product design, and wanted to make art and architecture that had
a similarly seductive appeal. Hamilton's collage *Just What Is It That
Makes Today's Homes So Different, So Appealing?* (1956), made from
American magazine advertisements, was the first work to achieve
iconic status. The next generation of students in London, including
Patrick Caulfield and David Hockney, also incorporated popular
culture into their collages and assemblages, and in the period
between 1959 and 1962 achieved public notoriety.

In the early 1960s, in America itself, the public saw for the first
time the works that since have become famous: Andy Warhol's

silkscreens of Marilyn Monroe, Roy Lichtenstein's comic-strip oils, Claes Oldenberg's gigantic vinyl burgers and ice cream cones, and Tom Wesselmann's nudes set in domestic settings that incorporate real shower curtains, telephones and bathroom cabinets. Public attention culminated in a large international exhibition mounted at the Sidney Janis Gallery in New York in 1962. Works by British, French, Italian, Swedish and American artists were grouped around the themes of the 'daily object', 'mass media', and the 'repetition' or 'accumulation' of mass-produced objects. It was a defining moment. Sidney Janis was the leading dealer in blue-chip European moderns and Abstract Expressionists, and his exhibition consecrated the work as the next art historical movement to be discussed and collected.

Pop Art spread throughout the rest of the USA and Europe via numerous gallery and museum exhibitions. Los Angeles was a particularly receptive site for the new art, with its less entrenched artistic traditions and young, wealthy population eager to collect contemporary work. Pop subjects (comic strips, consumer products, celebrity icons, advertising or pornography) and Pop themes (the elevation of 'low' art, Americana, suburbia and the myths and

Richard Hamilton
Just What Is It That Makes Today's Homes So Different, So Appealing?, 1956
Collage, 26.7 x 17.6 cm (10½ x 7 in.)
Kunsthalle Tübingen, Tübingen

With celebrity bodybuilder Charles Atlas and a pin-up glamour girl as the new domestic couple, and a comic strip and can of ham taking the place of a painting and a sculpture, Hamilton's collage seems to usher in a new era.

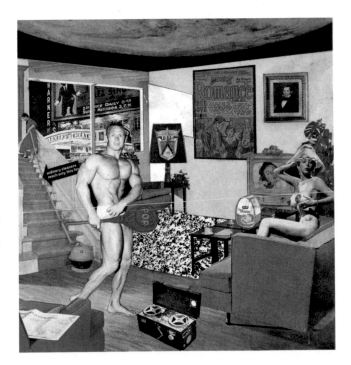

realities of the American Dream) were as quickly identified and established on the West Coast as on the East.

Pop artists embraced the middle classes and their interest in all that was new and modern. The artist's role changed too, enlivened by associations of glamour and celebrity. As Larry Rivers (see Neo-Dada) explained in 1963: 'For the first time in this country, the artist is "on-stage". He isn't just fooling around in a cellar with something that maybe no one will see. Now he is there in the full glare of publicity.' The impact of this change is still felt today. The popularity of Pop Art has waned little since its inception, and its impact on the art movements that followed – such as Op Art, Conceptual Art and Super-realism – was considerable.

Andy Warhol
Flowers (pink, blue, green), 1970
Colour screen print, 91.5 x 91.5 cm (36 x 36 in.)
National Gallery of Art, Washington, DC

Warhol's *Flower* screenprint series of 1970 is based on his series of *Flower* paintings of the 1960s, which were based on photographs of hibiscus flowers. The simplified, flattened forms, which seem to float, prompted a reviewer to see them like Matisse's cutouts 'set adrift on Monet's lily pond'.

KEY ARTISTS

Patrick Caulfield (1936–2005), UK
Richard Hamilton (1922–2011), UK
David Hockney (b.1937), UK
Robert Indiana (b.1928), USA
Roy Lichtenstein (1923–97), USA
Marisol (1930–2016), USA
Claes Oldenburg (b.1929), USA
Eduardo Paolozzi (1924–2005), UK
Andy Warhol (1928–87), USA
Tom Wesselmann (1931–2004), USA

KEY FEATURES

Images from advertising, mass media, popular culture and daily life
Repetition, accumulation

MEDIA

Painting, sculpture and design

KEY COLLECTIONS

Andy Warhol Museum, Pittsburgh, PA, USA
Fine Arts Museums of San Francisco, San Francisco, CA, USA
Museu Berardo, Lisbon, Portugal
Museum of Contemporary Art, Chicago, IL, USA
Phoenix Art Museum, Phoenix, AZ, USA
National Gallery of Art, Washington, DC, USA
Tate, London, UK

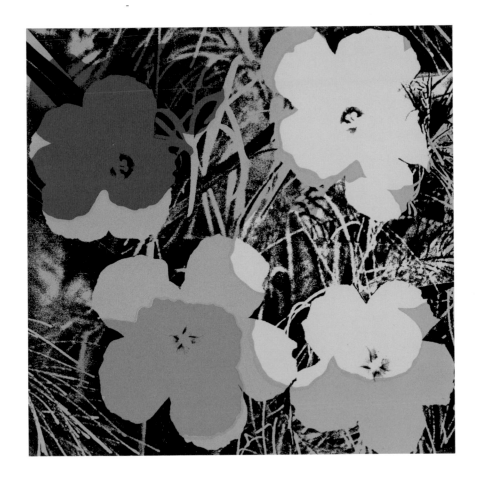

PERFORMANCE ART
c.1958 –

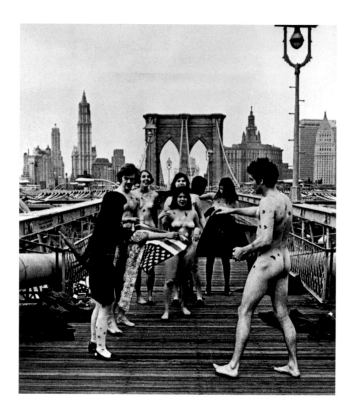

In the 1950s, influential American composer John Cage began collaborating with choreographer Merce Cunningham to create performance projects with musicians, dancers, poets and artists. This experimentation and cross-fertilization between theatre, dance, film, video and visual art was essential for the development of Performance Art. Performances, whether called Actions, Live Art or Happenings, allowed artists to traverse and blur boundaries between media and disciplines, art and life. The sense of liberation, for both artists and spectators, was infectious.

Performance gained momentum during the 1960s, with an explosion of different forms. These ranged from the 'action-

spectacles' of the Nouveaux Réalistes, in which performance was part of the creation of the art work, to the self-contained 'Happenings', which were themselves the 'artwork'; from jazz and poetry performances to the multimedia collaborative events by many artists, including Cage and Cunningham, the Neo-Dada artists, Nouveaux Réalistes and members of Fluxus. Performance also figured in the work of many Minimalist and Conceptual artists.

Performance Art grew out of a wide range of sources – including art, music hall, vaudeville, dance, theatre, rock-n-roll, musicals, film, circus, cabaret, club culture and political activism – and by the 1970s it was an established genre with its own history. It became increasingly accessible throughout the 1980s, through work by artists such as Laurie Anderson, whose sophisticated fusion of high art and popular culture brought Performance Art to a large international audience. Performance continues to appeal as the medium of choice for many artists, allowing the creation of richly layered pieces that can be both thought provoking and entertaining.

Yayoi Kusama
'Anti-War' Naked
Happening and Flag
Burning at Brooklyn
Bridge, 1968
Photograph of
performance

**Kusama targeted
important locations
in New York City
for her anti-war and
anti-establishment
performances. Here,
the performers are
'signed' by her signature
polka dots (see also
page 94).**

KEY ARTISTS

Laurie Anderson (b.1947), USA
John Cage (1912–92), USA
Merce Cunningham (1919–2009), USA
Allan Kaprow (1927–2006), USA
Yves Klein (1928–63), France
Yayoi Kusama (b.1929), Japan
Robert Rauschenberg (1925–2008), USA

KEY FEATURES

Juxtaposition of elements and mosaics of images and sounds
Non-narrative structure
Collaboration between different sorts of artists
Experimental, transgressive
Humour, satire

MEDIA

Performance, film and photography

KEY COLLECTIONS

Centre Georges Pompidou, Paris, France
Dia Center for the Arts, Beacon, New York, NY, USA
Electronic Arts Intermix, New York, NY, USA
Tate, London, UK

FUNK ART
c.1958–70s

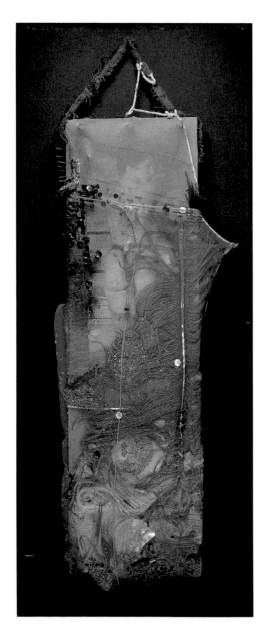

Bruce Conner
BLACK DAHLIA, 1960
Mixed-media assemblage,
67.9 x 27.3 x 7 cm
(26¾ x 10¾ x 2¾ in.)
Museum of Modern Art,
New York

**Conner's composition of
photographs, sequins,
feathers, lace and nylon
stockings comments on
the enduring voyeuristic
interest in the unsolved
sensational murder
in 1947 of aspiring
actress Elizabeth Short,
nicknamed the Black
Dahlia (later the subject
of James Ellroy's novel of
the same name).**

During the late 1950s works by a number of artists in California, such as Bruce Conner, George Herms and Ed Kienholz, were described as 'funky' – slang for bad smelling. The term referred to their use of junk materials, or as Kienholz put it, 'the leftovers of human experience'. Funk artists used shock tactics to highlight issues too often ignored, such as abortion, violence, capital punishment, mental illness, miscarriages of justice, fear of nuclear war and the victimization of women.

Their work carried on the tradition of social critique and protest of the Social Realists and the Magic Realists of the 1930s, and intersected with Neo-Dada and Beat Art. While artists of all these 'movements' shared the belief that art must be in and of this world, not an escape from it, Funk Art exhibits a greater moral outrage than most Neo-Dada work and is devoid of the spiritual or mystical dimension of much Beat Art.

During the 1960s Funk Art also came to refer to another group of artists, many based in San Francisco, including Robert Arneson, David Gilhooly and Viola Frey. Their vision was less grim and more humorous, more like a regional Pop-Funk hybrid. Many worked in ceramics, fusing high art and craft, visual and verbal puns.

KEY ARTISTS
Robert Arneson (1930–92), USA
Bruce Conner (1933–2008), USA
Viola Frey (1933–2004), USA
David Gilhooly (1943–2013), USA
George Herms (b.1935), USA
Ed Kienholz (1927–94), USA

KEY FEATURES
Biting critique, black humour, junk materials

MEDIA
Mixed-media assemblage, installation and environments
Ceramics

KEY COLLECTIONS
Kawamura Memorial DIC Museum of Art, Sakura, Japan
Moderna Museet, Stockholm, Sweden
Museum Ludwig, Cologne, Germany
Norton Simon Museum, Pasadena, CA, USA
San Francisco Museum of Modern Art, San Francisco, CA, USA

NOUVEAU RÉALISME
1960–70

The Nouveaux Réalistes (New Realists) were a group of European artists championed by Pierre Restany, the French art critic. Restany founded the group in Paris in 1960 declaring that: 'New realism = new perceptive approaches to the real.' This basic platform provided an identity for collective activity and encompassed the notably diverse work of Arman, César, Yves Klein, Niki de Saint Phalle, Daniel Spoerri, Jean Tinguely and others.

It was common for the Nouveaux Réalistes to incorporate objects from the everyday world into their work, be it the torn posters of Raymond Hains, an 'accumulation' of objects by Arman, a trap painting (usually of the leftovers of a meal) by Spoerri, or a compression of a scrapped automobile by César. This 'poetic recycling' gave discarded or overlooked objects new life as art.

Other works embraced 'creative destruction' and are results of actions or performances. Klein's *Anthropometries*, in which the bodies of nude women were used as 'living brushes' to make paintings, are perhaps the best known. Other examples include: Arman's *Colères* (fits of rage), collections of smashed objects displayed in boxes; Saint Phalle's *Tirs* (shooting paintings), which were completed by firing a rifle at an assemblage embedded with paint-filled sacks; and Tinguely's self-destructing junk machines. The Nouveaux Réalistes took great pleasure in exploring different processes of making art and shared their artistic inspirations and motivations with the American Neo-Dada artists.

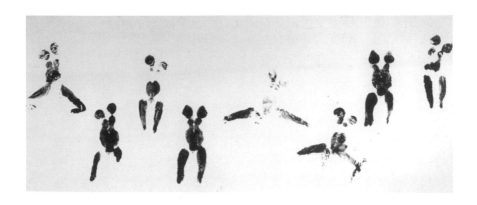

Yves Klein
Untitled Anthropometry,
1960
Pure pigment and
synthetic resin on paper
laid down on canvas,
144.8 x 299.5 cm
(57 x 117⅞ in.)
Museum of Modern Art,
New York

In his *Anthropometries*
(body paintings), Klein
used models as living
brushes. The models
smeared themselves with
his own patented paint
(International Klein Blue)
and pressed themselves
against surfaces to make
an imprint, according to
Klein's instructions.

KEY ARTISTS

Arman (1928–2005), France
César (1921–99), France
Raymond Hains (1926–2005), France
Yves Klein (1928–62), France
Niki de Saint Phalle (1930–2002), France–USA
Daniel Spoerri (b.1930), Switzerland
Jean Tinguely (1925–91), Switzerland

KEY FEATURES

Experimental processes – accumulation, appropriation,
 compression, creative destruction
Unusual materials

MEDIA

Painting, collage, assemblage, sculpture, installation and
 performance

KEY COLLECTIONS

Centre Georges Pompidou, Paris, France
Moderna Museet, Stockholm, Sweden
Museum of Modern and Contemporary Art, Nice, France
Museum of Modern Art, New York, NY, USA
Stedelijk Museum, Amsterdam, Netherlands
Tate, London, UK
Walker Art Center, Minneapolis, MN, USA

FLUXUS
1961–

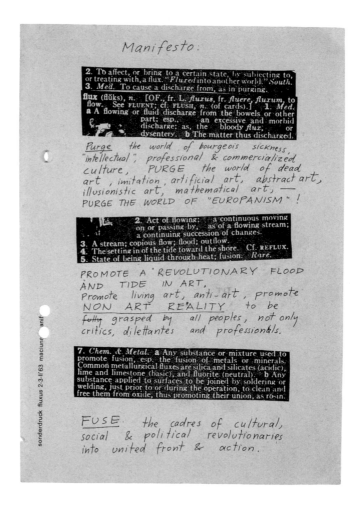

The basic idea behind Fluxus is that life itself can be experienced as art. George Maciunas invented the word (from 'flux', to flow) in 1961 to highlight the ever-changing nature of the group and to establish links between its varied activities, media, disciplines, nationalities, genders, approaches and professions. Most of the work of this informal international group involved collaboration, either

George Maciunas
Fluxus Manifesto,
February 1963
Offset on paper
Museum of Modern Art,
New York

**For Maciunas, Fluxus
was 'the fusion of Spike
Jones, vaudeville, gag,
children's games and
Duchamp'.**

with other artists or with the viewer, and Fluxus soon grew into an ever-expanding community of artists from various disciplines and nationalities working together in various ways.

Fluxus can be seen (as its own members did) as a strain of the Neo-Dada movement of the 1950s and 1960s, related to Beat Art, Funk Art and Nouveau Réalisme. Like their contemporaries, Fluxus artists sought a closer integration of art and life, and a more democratic approach to making, receiving and collecting art. They were anarchic activists and utopian radicals. A 'do-it-yourself' nature permeates Fluxus work, much of which exists as written directions to be carried out by others. Throughout the 1960s and 1970s, there were numerous Fluxus festivals, concerts and tours, as well as Fluxus newspapers, anthologies, films, food, games, shops, exhibitions, and even Fluxweddings and Fluxdivorces. Although its heyday was in the 1960s and 1970s, Fluxus continues to develop today, taking advantage of new technologies, such as the internet.

KEY ARTISTS
George Brecht (1926–2008), USA
Dick Higgins (1938–98), UK
Alison Knowles (b.1933), USA
George Maciunas (1931–78), Lithuania–USA
Yoko Ono (b.1933), Japan
Wolf Vostell (1932–98), Germany
Robert Watts (1923–88), USA

KEY FEATURES
Anarchic, playful, experimental
Many written instructions, publications

MEDIA
Performance, mail art, games, concerts and publications

KEY COLLECTIONS
Hamburger Kunsthalle, Hamburg, Germany
Harvard Art Museums, Cambridge, MA, USA
Henie Onstad Art Centre, Høvikodden, Norway
Museum of Modern Art, New York, NY, USA
Queensland Art Gallery, Brisbane, Australia
Tate, London, UK
Walker Art Center, Minneapolis, MN, USA
Whitney Museum of American Art, New York, NY, USA

POST-PAINTERLY ABSTRACTION
1964–70s

American critic Clement Greenberg coined the term Post-Painterly Abstraction in 1964 for an exhibition he curated at the Los Angeles County Museum of Art. His term incorporated diverse styles: the hard-edge painting of Ellsworth Kelly and Frank Stella, Helen Frankenthaler's stain paintings, paintings by the Washington Color School artists Morris Louis and Kenneth Noland, and the systemic paintings of Josef Albers and Ad Reinhardt.

All these different types of American abstract painting grew out of Abstract Expressionism in the late 1950s and early 1960s, and in some ways reacted against it. In general, the new abstract artists shunned the overt emotionalism of Abstract Expressionism and rejected its expressive gestural brushstrokes and tactile surfaces in favour of cooler, more anonymous styles of handling. Though they shared certain visual characteristics and painting techniques with the Abstract Expressionist artists Barnett Newman and Mark Rothko, they did not share the older artists' transcendental beliefs about art. Instead, they tended to stress painting as object rather than illusion. Shaped canvases stressed the unity between the painted image and the form of the canvas. Following Reinhardt's 'art for art's sake' stance, they rejected the social, utopian aspirations of Concrete artists, whose work sometimes resembles their own.

Frank Stella
Nunca Pasa Nada, 1964
Oil on canvas,
270 x 540 cm
(106⅓ x 212⅔ in.)
Lannan Foundation,
New York

Stella's black stripe paintings – large canvases of stripes painted freehand over a precise geometric drawing with the raw canvas showing between – brought together aspects of gestural and geometric abstraction, and seemed to mock both, purifying gestural abstraction, and sullying geometric abstraction.

KEY ARTISTS
Josef Albers (1888–1976), Germany–USA
Helen Frankenthaler (1928–2011), USA
Ellsworth Kelly (1923–2015), USA
Morris Louis (1912–62), USA
Kenneth Noland (1924–2010), USA
Ad Reinhardt (1913–67), USA
Frank Stella (b.1936), USA

KEY FEATURES
Clearly defined contours, simple motifs, pure colours
Stained unprimed canvas
Abstract, anonymous handling

MEDIA
Painting

KEY COLLECTIONS
Kawamura Memorial DIC Museum of Art, Sakura, Japan
Museum of Modern Art, New York, NY, USA
National Gallery of Art, Washington, DC, USA
Portland Art Museum, Portland, OR, USA
Smithsonian American Art Museum, Washington, DC, USA
Solomon R. Guggenheim Museum, New York, NY, USA
Tate, London, UK
Whitney Museum of American Art, New York, NY, USA

OP ART
1965–

Op Art specifically employs optical phenomenon to confound the normal processes of perception. Composed of precise geometric patterns in black and white, or of juxtapositions of high-keyed colours, Op Art paintings vibrate, dazzle and flicker, creating moiré effects, illusions of movement or afterimages.

By the mid-1960s, the fashion-conscious New York art world was already announcing the demise of Pop Art, and the search was on for its replacement. In 1965 an exhibition called 'The Responsive Eye' at the Museum of Modern Art in New York provided the answer. Work by artists including Richard Anuszkiewicz, Michael Kidner, Bridget Riley and Victor Vasarely stole the show. Prior to the opening of the exhibition, their work had been dubbed Op Art (short for 'optical art', with a ringing reference to Pop), not by the artists or critics, but by the media.

The name first appeared in *Time* magazine in October 1964, and by the time of the show it was in common usage. It rapidly caught the popular imagination – visitors arrived at the preview of 'The Responsive Eye' dressed in Op Art-inspired clothing – and the new style spread into fashion, interiors and graphics, becoming part of the imagery of the Swinging Sixties.

Bridget Riley
Cataract 3, 1967
Emulsion PVA on
canvas, 222 x 223 cm
(87½ x 87¾ in.)
British Council collection

Riley made her name with her striking use of geometric shapes in black and white. She then moved on to include contrasting colours and tonal variations. Whether black and white or colour, an effect of rhythm and distortion is created.

KEY ARTISTS
Richard Anuszkiewicz (b.1930), USA
Michael Kidner (1917–2009), UK
Bridget Riley (b.1931), UK
Victor Vasarely (1908–97), Hungary–France

KEY FEATURES
Optical illusions
Geometric abstraction
Black and white or bright colours

MEDIA
Painting, sculpture, fashion and graphics

KEY COLLECTIONS
Albright-Knox Art Gallery, Buffalo, NY, USA
Calouste Gulbenkian Museum, Lisbon, Portugal
Fondation Vasarely, Aix-en-Provence, France
Henie Onstad Art Centre, Høvikodden, Norway
Museum of Modern Art, New York, NY, USA
Tate, London, UK

BEYOND THE AVANT-GARDES
1965–TODAY

-

**The artist, like the tightrope dancer,
goes in various directions, not because he is skilful
but because he is unable to choose only one**

-

Mimmo Paladino

1985

MINIMALISM
c.1965–70s

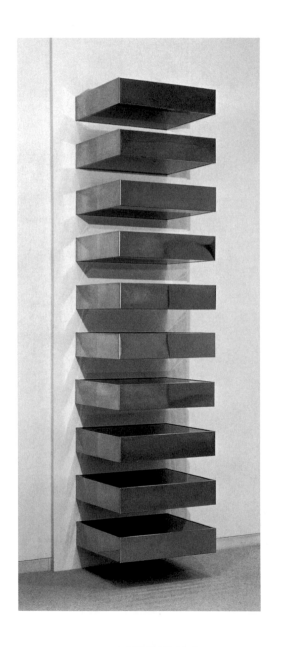

Donald Judd
Untitled, 1969
Brass and coloured
fluorescent Plexiglass on
steel brackets, made up of
ten parts with 15.2 cm (6
in.) between each. Each
part: 15.5 x 60.9 x 68.7
cm (6⅛ x 24 x 27 in.);
overall: 295.9 x 61 x 68.6
cm (116½ x 24 x 27 in.)
Hirshhorn Museum
and Sculpture Garden,
Washington, DC

**In works such as his
wall stacks, Judd
confounds the traditional
presentations of
painting (flat on a wall)
and sculpture (on a
plinth), prompting the
basic question: are the
wall stacks painting or
sculpture? They use
colour like painting,
but protrude from the
wall, so that the wall
itself becomes a part
of the work.**

Minimalism was one of many labels (including Primary Structures, Unitary Objects, ABC Art and Cool Art) applied by critics to describe the apparently simple, geometric structures that Donald Judd, Robert Morris, Dan Flavin, Carl Andre and others were exhibiting in New York in the mid-1960s. The artists themselves did not like the label for its implication that their work was simplistic and devoid of 'art content'. By restricting the elements at work in each object, their art creates complex effects.

A constant theme in Judd's art is the interplay between negative and positive spaces in actual objects, and the interaction of objects with their immediate environment. Morris's mirror-cube boxes point to similar concerns. In the interaction between the huge mirrored objects, the viewers and the gallery space, an ever-changing artwork that dramatizes the theatricality of the viewing experience is created. Flavin is known for his sensuous fluorescent light-tube installations, and Andre for his arrangements of units of ordinary, factory-finished materials on the floor, questioning the rightful space of sculpture and its relationship to the human body.

By focusing on the effects of context and the theatricality of the viewing experience, Minimalism exerted an indirect but powerful influence on later developments in Conceptual Art and Performance, as well providing a foil for the rise of Postmodernism.

KEY ARTISTS
Carl Andre (b.1935), USA
Dan Flavin (1933–96), USA
Donald Judd (1928–94), USA
Robert Morris (b.1931), USA

KEY FEATURES
Geometric structures made of plywood, aluminium, Plexiglass, iron, stainless steel, bricks, fluorescent light tubes

MEDIA
Painting, sculpture, assemblage, installation and environments

KEY COLLECTIONS
Chinati Foundation, Marfa, TX, USA
Hirshhorn Museum and Sculpture Garden, Washington, DC, USA
Museum of Modern Art, New York, NY, USA
The Menil Collection, Houston, TX, USA
Tate, London, UK

CONCEPTUAL ART
c.1965 –

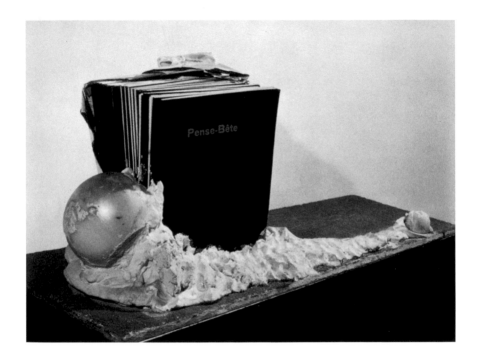

Conceptual Art came into its own as a category of art in the late
1960s and early 1970s. Although defined first in New York, it soon
became a vast international movement. The basic precept is that
ideas or concepts constitute the real artwork. Whether in Body Art,
Performance, Video Art or Fluxus activities, the object, installation,
action or documentation is acknowledged as no more than a vehicle
for presenting the concept. At its most extreme, Conceptual Art
foregoes the physical object completely, using verbal or written
messages to convey the ideas.

 Artists consciously used formats that are often visually
uninteresting, in a traditional art sense, in order to focus attention

on the central idea or message. The activities or thoughts presented could have taken place elsewhere spatially or temporally, or even simply in the viewer's head. Implicit was a desire to demystify the creative act and to empower both the artist and the viewer beyond the concerns of the art market.

While many early Conceptual artists were preoccupied with the language of art, during the 1970s others looked outwards, producing work that included natural phenomena; narrative and storytelling tinged with humour or irony; explored the power of art to transform lives and institutions; and work that pursued a critique of the power structures of the art world, and the more general social, economic and political conditions of the wider world.

Marcel Broodthaers
Pense-Bite, 1963
Books, paper, plaster, plastic spheres and wood, 98 x 84 x 43 cm (38⅝ x 33⅛ x 16⅞ in.)
Collection of the Flemish community, SMAK: the Municipal Museum of Contemporary Art, Ghent

Broodthaers, a poet who turned to art in the mid-1960s, considers the condition of representation through puzzle-like works in which words, images and objects are constantly interacting. This sculpture was made from copies of his last book of poetry, embedded in plaster.

KEY ARTISTS

Joseph Beuys (1921–86), Germany
Marcel Broodthaers (1924–76), Belgium
Daniel Buren (b.1938), France
Hans Haacke (b.1936), Germany–USA
On Kawara (1932–2014), Japan
Joseph Kosuth (b.1945), USA
Sol LeWitt (1928–2007), USA
Piero Manzoni (1933–63), Italy
Lawrence Weiner (b.1940), USA

KEY FEATURES

Interest in language, appeal to the viewer's intellect
Questioning, challenging

MEDIA

Documents, written proposals, film, video, performance, photography, installation, maps, wall drawings and mathematical formulae

KEY COLLECTIONS

Art Gallery of Ontario, Toronto, ON, Canada
DeCordova Sculpture Park and Museum, Lincoln, MA, USA
Hamburger Bahnhof, Museum for Contemporary Art, Berlin, Germany
Hood Museum of Art, Hanover, NH, USA
HEART – Herning Museum of Contemporary Art, Herning, Denmark
Museum of Modern Art, New York, NY, USA
Tate, London, UK

BODY ART
c.1965–

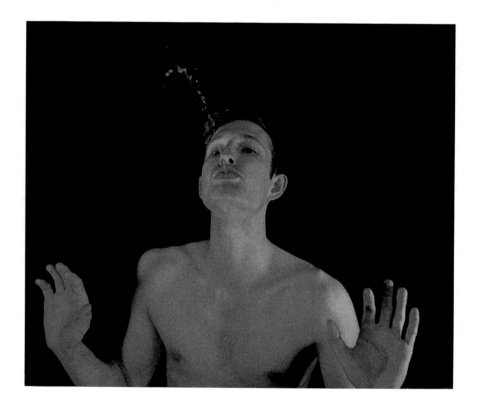

Body Art uses the body, usually the artist's own, as a medium.
Since the late 1960s, it has been one of the most popular and
controversial forms of art. In many ways it represents a reaction
against the impersonality of Conceptual and Minimalist Art. But,
as the product of the working through of an idea or issue, Body
Art can also be seen as an extension of both these movements. In
cases where it takes the form of a public ritual or performance, it
also overlaps with Performance Art, though it is frequently made
privately and then communicated publicly via documentation.
Audiences of Body Art may be passive observers, voyeurs or active

participants. Extremely emotional responses can be elicited by works that are intentionally alienating, boring, shocking, thought-provoking or funny.

Artists making Body Art present and question a variety of interpretations of the role of the artist (the artist as a work of art or as a social and political commentator), and of the role of art itself (art as an escape from daily life, art as an exposé of social taboos, art as a means of self-discovery, art as narcissism). The body provides a powerful means for exploring wide-ranging issues, including identity, gender, sexuality, illness, death and violence. The works range from sadomasochistic exhibitionism to communal celebrations, from social commentary to comedy.

Bruce Nauman
Self-Portrait as a Fountain,
1966–70
Colour photograph,
edition of eight,
50 x 60 cm
(19¾ x 23¾ in.)
Leo Castelli Gallery,
New York

'The true artist is an amazing luminous fountain.' The body is a recurring theme in Nauman's work, whether translated into neon or video. His work explores the body in space, the psychological nuances and power games of human relationships, body language, the body of the artist as a source material and the self-searching narcissism of the artist.

KEY ARTISTS

Marina Abramović (b.1946), Serbia
Vito Acconci (b.1940), USA
Chris Burden (1946–2015), USA
Gilbert (Proesch; b.1943), Italy & George (Passmore; b.1942), UK
Rebecca Horn (b.1944), Germany
Bruce Nauman (b.1941), USA
Carolee Schneemann (b.1939), USA

KEY FEATURES

Fusion of art and life
Questioning, challenging, often shocking
Issue-driven

MEDIA

Painting, sculpture, photography, performance and mixed media

KEY COLLECTIONS

Castello di Rivoli Museo d'Arte Contemporanea, Rivoli, Italy
Electronic Arts Intermix, New York, NY, USA
Museum of Contemporary Art, Los Angeles, CA, USA
Tate, London, UK

SUPER-REALISM
c.1965–

Super-realism was one of many names (others included Photo-realism, Hyper-realism and Sharp-Focus Realism) applied to a particular type of painting and sculpture that became prominent during the 1970s, especially in the USA. During the heyday of abstraction, Minimalism and Conceptual Art, these artists deliberately turned to making descriptive, representational painting and sculpture. Most of the paintings copy photographs and many of the sculptures are constructed from body casts.

Chuck Close created billboard-scale portraits of his friends and himself with an airbrush and a minimal amount of pigment to achieve a smooth photograph-like surface. Richard Estes combines aspects of several photographs to create images that are of uniform sharp focus, seemingly more 'true' than a photograph. For his 'photo-paintings', Gerhard Richter transfers to canvas 'found' photographs from newspapers and magazines or his own snapshots. He blurs them with a dry brush to incorporate their graininess, deliberately bringing out the 'flaws' of amateur photography.

Duane Hanson and John DeAndrea both made lifelike sculptures, but whereas DeAndrea's nudes are the young, attractive ideal, Hanson's figure groupings of different types of ordinary Americans can be read as commentary or humorous self-awareness. His figures are made from direct casts of real people, constructed in reinforced polyester resin and fibreglass, and dressed in real clothes. The result is an amazing, unsettling likeness.

Chuck Close
Mark, 1978–9
Acrylic on canvas, 274.3 x 213.4 cm (108 x 84 in.)
Pace Gallery, New York

Close created his huge portraits by transferring a photograph onto a grid and then painting square by square with an airbrush and a minimal amount of pigment. The attention to detail of this painstaking process is evident in the bulges, pores and hairs of the sitters and in the retention of the out-of-focus areas of the photograph. The combination of the large-scale and 'impersonal' technique creates images that are at once monumental, intimate and distinctly Close's own.

KEY ARTISTS

Chuck Close (b.1940), USA
John DeAndrea (b.1941), USA
Richard Estes (b.1936), USA
Duane Hanson (1925–96), USA
Malcolm Morley (b.1931), UK–USA
Gerhard Richter (b.1932), Germany

KEY FEATURES

Attention to detail, careful craftsmanship
Cool, impersonal appearance
Common or industrial subject matter

MEDIA

Painting and sculpture

KEY COLLECTIONS

Akron Art Museum, Akron, OH, USA
Museum of Contemporary Art, Chicago, IL, USA
National Gallery of Modern Art, Edinburgh, UK
Tate, London, UK
Walker Art Center, Minneapolis, MN, USA
Whitney Museum of American Art, New York, NY, USA

VIDEO ART
1965–

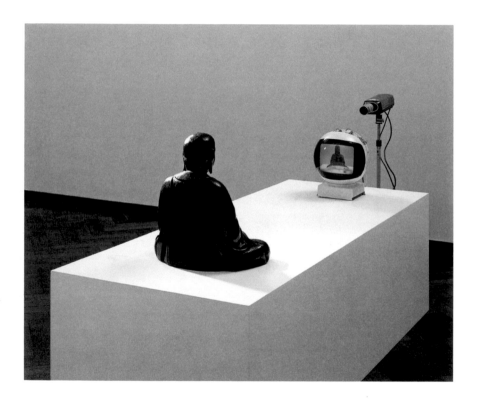

In the 1960s, as Pop artists were introducing imagery from mass culture into galleries, a group of artists took on the most powerful new mass medium – television. First generation Video artists appropriated the rich syntax of the language of television – spontaneity, discontinuity, entertainment – in many cases to expose the dangers of such a culturally powerful medium. Early Video artists fused global-communication theories with elements of popular culture to produce videotapes, single and multi-channel productions, international satellite installations and multi-monitor sculptures. Artists experimented with their new medium as

completely as painters explored theirs: new production techniques were developed, and Video Art became increasingly sophisticated.

In the 1980s a new generation of artists specializing in Video Art emerged and there was a major shift in the role of the artist. Early productions often featured the artist in the role of performer or behind the camera, but the artist now took on the role of producer or editor, structuring meaning in post-production. Further technological advances in projection, and the merging of video with the computer since the late 1980s, have led to larger and more complex works of Video Art, with the liberating of video from its black box allowing for monumental projections and immersive experiences.

Nam June Paik
TV-Buddha, 1974
Video installation, closed-circuit TV, eighteenth-century Buddha statue, 160 x 215 x 80 cm (63 x 84²/₃ x 31½ in.) Stedelijk Museum, Amsterdam

'I make technology ridiculous,' Paik said. He was a pioneer of Video Art and appropriated the rich syntax of the language of television in order to expose the dangers of such a culturally powerful medium. In this installation, a statue of Buddha takes the place of the television viewer and watches a video of himself on the screen opposite.

KEY ARTISTS

Matthew Barney (b.1967), USA
Stan Douglas (b.1960), Canada
Joan Jonas (b.1936), USA
Steve McQueen (b.1969), UK
Ana Mendieta (1948–86), Cuba
Tony Oursler (b.1957), USA
Nam June Paik (1932–2006), Korea–USA
Bill Viola (b.1951), USA

KEY FEATURES

Video/film as the core medium

MEDIA

Performance, video, assemblage and installation

KEY COLLECTIONS

Electronic Arts Intermix, New York, NY, USA
Castello di Rivoli Museo d'Arte Contemporanea, Rivoli, Italy
Museum of Modern Art, New York, NY, USA
Smithsonian American Art Museum, Washington, DC, USA
Stedelijk Museum, Amsterdam, Netherlands
Tate, London, UK
Walker Art Center, Minneapolis, MN, USA
Whitney Museum of American Art, New York, NY, USA

ARTE POVERA
1967–

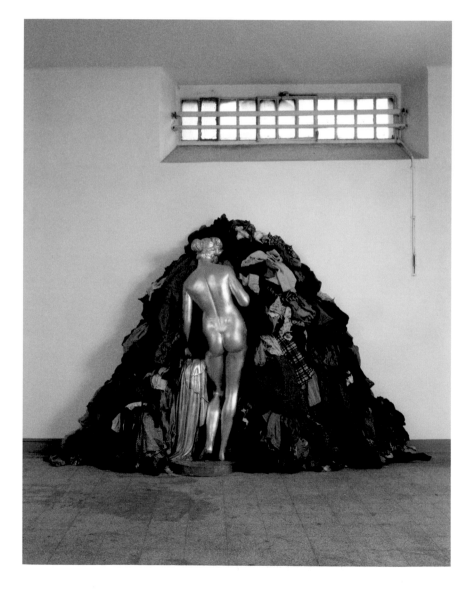

Arte Povera (Italian: impoverished art) was the term coined by Italian curator-critic Germano Celant in 1967 to refer to a group of artists in northern Italy with whom he had been working since 1963. The name alludes to the 'humble' (or 'poor') non-art materials they used in their installations, assemblages and performances, including rags, vegetables and even live animals. Celant wrote a manifesto, in which he explained that their work was 'poor' in the sense that it was stripped of associations imposed by tradition and social convention, and stressed the artists' aim of 'shattering existing cultural codes'.

The richly layered works are characterized by unexpected juxtapositions of objects or images; by the use of contrasting materials; and by the fusion of past and present, nature and culture, and art and life. Arte Povera was the Italian response to the general spirit of the times, as artists were pushing back the boundaries of art, expanding the use of materials and questioning the nature and definition of art itself as well as its role in society. They shared many of these interests with other practioners of the period, such as Fluxus, Performance and Conceptual artists.

Michelangelo Pistoletto
Golden Venus of the Rags,
1967–71
Concrete with mica and
rags, 180 x 130 x 100 cm
(70⅞ x 51⅛ x 39⅜ in.)
Marguerite Steed
Hoffman collection

Dialogues with history run through much Arte Povera work, as does a fusion of classical and contemporary imagery. Pistoletto's *Golden Venus of the Rags* reflects the fabric of Italian society where the surreal juxtapositions of Pittura Metafisica are a part of everyday life. It also seems to pose the question: is the idealized, perfect past preferable to the colour and chaos of the present?

KEY ARTISTS
Giovanni Anselmo (b.1934), Italy
Luciano Fabro (1936–2007), Italy
Jannis Kounellis (1936–2017), Greece–Italy
Mario Merz (1925–2003), Italy
Michelangelo Pistoletto (b.1933), Italy

KEY FEATURES
Use of non-art materials, such as wax, gilded bronze, copper, granite, lead, terracotta, cloth, neon, steel, plastic, vegetables, even live animals

MEDIA
Sculptures, installation, assemblage and performance

KEY COLLECTIONS
Castello di Rivoli Museo d'Arte Contemporanea, Rivoli, Italy
Fondazione Merz, Turin, Italy
HEART – Herning Museum of Contemporary Art, Herning, Denmark
Kunstmuseum Liechtenstein, Vaduz, Liechtenstein
Kunstmuseum Wolfsburg, Wolfsburg, Germany
Museo del Novecento, Milan, Italy
Museo di Capodimonte, Naples, Italy

EARTH ART
c.1968 –

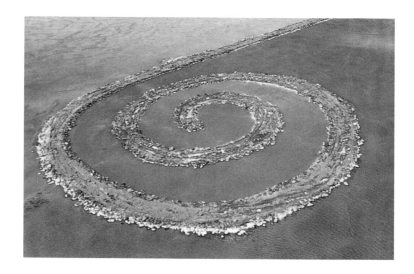

Earth Art – also known as Land Art or Earthworks – emerged in the late 1960s as artists explored the potential of landscape and the environment as both material and site for their art. Rather than representing nature, they utilize it directly in their work: art is made in, on, and in some cases, from, nature.

Earth Art can take the form of immense sculptures in the landscape (such as Nancy Holt's *Sun Tunnels*), monumental sculptures made from nature itself (excavations by Michael Heizer and James Turrell) and works that use photography, diagrams or written text to record temporary interventions in the landscape (Richard Long's documentations of his walks in remote landscapes).

On the Great Salt Lake in Utah, USA, Robert Smithson transformed an industrial wasteland into the most famous and romantic earthwork of all, *Spiral Jetty* (1970), a spiral road of black basalt stones and earth projecting into the water of the lake. *Lightning Field* (1977) by Walter De Maria is another seminal piece of Earth Art. It consists of 400 steel poles arranged in a grid to encourage lightning and interact with the dramatic high desert

Robert Smithson
Spiral Jetty, 1970
Rock, earth and salt crystals; coil: 457.2 x 3.81 m (1,500 x 15 ft)
Salt Lake, UT

Smithson was unaware that the water levels of the lake were unnaturally low when he made the work and soon it was engulfed in water. In 2002, after years of drought, *Spiral Jetty* made a dramatic reappearance – complete with a new look. In the interim the rocks had become encrusted with salt crystals, creating a brilliant white-on-white relief.

landscape in New Mexico. Collaborators Christo and Jeanne-Claude created monumental environmental works around the world that temporarily transformed sites through a combination of astounding spectacle and heroic effort.

KEY ARTISTS
Christo (b.1935), Bulgaria-USA, and Jeanne-Claude (1935–2009), France–USA
Walter De Maria (1935–2013), USA
Michael Heizer (b.1944), USA
Nancy Holt (1938–2014), USA
Charles Jencks (b.1939), USA
Maya Lin (b.1959), USA
Richard Long (b.1945), UK
Charles Ross (b.1937), USA
Robert Smithson (1938–73), USA
James Turrell (b.1943), USA

KEY FEATURES
Art made in, on, or from, nature

MEDIA
Sculpture, installation, environments, photography and film

KEY COLLECTIONS
Dia Center for the Arts, New York, NY, USA
Tate, London, UK

KEY SITES
Walter De Maria, *Lightning Field*, Western New Mexico, USA
Michael Heizer, *Double Negative*, Overton, NV, USA
Nancy Holt, *Sun Tunnels*, Great Basin Desert, UT, USA
Charles Jencks, *Crawick Multiverse*, Sanquhar, Dumfries, UK
Maya Lin, *Eleven Minute Mile*, Wanås, Sweden
Robert Morris, Piet Slegers, Richard Serra, Marinus Boezem, Daniel Libeskind, Antony Gormley, Paul de Kort, *Land Art Flevoland*, Netherlands
Charles Ross, *Star Axis*, Chupinas Mesa, NM, USA
Robert Smithson, *Broken Circle/Spiral Hill*, Emmen, Netherlands
Robert Smithson, *Spiral Jetty*, Great Salt Lake, UT, USA
James Turrell, *Roden Crater*, Painted Desert, AZ, USA

SITE WORKS
c.1970 –

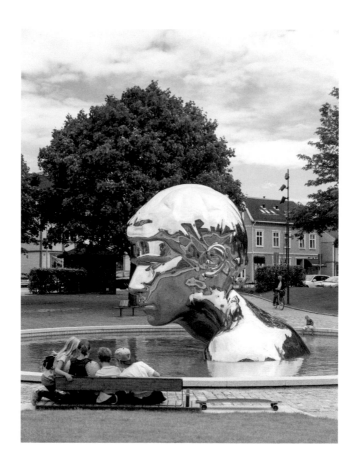

Since the 1950s artists have been taking art out of museums and into the streets or countryside. During the 1960s, the phrase 'site-specific' was increasingly used to describe an artwork that explored the physical context in which it was placed – whether gallery, city square or hilltop – so that the context became an integral part of the work itself.

Pop artist Claes Oldenburg's *Batcolumn* (1977), a steel baseball bat rising from the centre of Chicago, is an early example. It suits its location in practical ways (the open latticework steel construction allows it to survive the gales of the Windy City) and also alludes to the character of the region, with a nod of respect to the local steel industry and the city's devotion to baseball. *Angel of the North* (1998) by Antony Gormley, a 20-metre (66-foot) high steel angel, is located in a former coal mining area in northeast England. Finn Eirik Modahl's *Genesis/unge Olav* (Norwegian: young Olav; 2016), a giant youth emerging from a pool of water, is a site-specific celebratory landmark sculpture in Sarpsborg, Norway. It reaches back in time to reference the city's founding father while acknowledging the continual evolution and redefinition that cities and nations must undergo as they face the future. These three examples reference and connect with their surroundings and inhabitants, and have been embraced by the public as places to visit.

Finn Eirik Modahl
Genesis/unge Olav, 2016
Hand-hammered 5 mm-
316L-molybdenum steel,
sculpture: 500 x 600 cm
(197 x 236¼ in.)
Sarpsborg, Norway

Modahl's giant sculpture of a young Olav (founder of Sarpsborg and Norway's patron saint) emerging from a pool of water is a site-specific sculpture that draws on the history of its site and the impact of St Olav and water as defining features of Sarpsborg. The specificity of Modahl's *Genesis* combined with its universal aspects and commanding presence should provide it with a lasting appeal.

KEY ARTISTS
Alfio Bonanno (b.1947), Italy–Denmark
Daniel Buren (b.1938), France
Antony Gormley (b.1950), UK
Finn Eirik Modahl (b.1967), Norway
Claes Oldenburg (b.1929), Sweden–USA
Richard Serra (b.1939), USA

KEY FEATURES
The context of the artwork is an integral component of the work

MEDIA
Sculpture, installation and environments

KEY COLLECTIONS
Dia Center for the Arts, New York, NY, USA

KEY SITES
Alfio Bonanno, *Himmelhøj*, Copenhagen, Denmark
Daniel Buren, *Deux Plateaux*, Palais Royal, Paris, France
Antony Gormley, *Angel of the North*, Gateshead, UK
Finn Eirik Modahl, *Genesis/unge Olav*, Sarpsborg, Norway
Claes Oldenburg, *Batcolumn*, Chicago, IL, USA

POSTMODERNISM
c.1970 –

Postmodernism refers to certain new forms of expression in all the arts in the last quarter of the twentieth century. It was originally applied to architecture in the mid-1970s to describe buildings that abandoned clean, rational, minimalist forms in favour of ambiguous, contradictory structures enlivened by playful references to historical styles, borrowings from other cultures and an exuberant use of startlingly bold colours.

Where Modernism aimed to create a unifying moral and aesthetic utopia, Postmodernism celebrated late twentieth-century pluralism. An aspect of this pluralism is the nature of the mass media and the universal proliferation of images in print and electronic form – what French thinker Jean Baudrillard called 'an ecstasy of communication'. If we perceive reality not directly, but through representations, do those representations *become* our reality? What, then, is truth? In what sense is originality possible? These notions have crucially influenced architects, artists and designers. In much Postmodernist work the issue of representation is the very focus: motifs or images from past work are 'quoted' (or 'appropriated') in new and unsettling contexts, or stripped of their conventional meanings ('deconstructed').

Designers also embraced Postmodernist techniques. A dissatisfaction with the order and uniformity associated with the Bauhaus led to innovations from the 1960s, with designers mixing highbrow and lowbrow, experimenting with colours and textures and borrowing decorative motifs from the past, in an approach also called 'adhocism'.

Charles Moore
Piazza d'Italia, 1975–80
New Orleans, LA

Moore's piazza is an icon of Postmodernism, revelling in its theatricality and presenting a witty montage of classical architectural motifs in the form of a stage set.

In the visual arts, as in architecture and design, Postmodernism has aimed to express the experience of living at the end of the twentieth century and the beginning of the twenty-first. Often it has engaged directly with social and political issues. Starting with the idea that art has formerly served a dominant social type – the white, middle-class male – Postmodernist artists have chosen to highlight other identities previously marginalized, in particular environmental, ethnic, sexual and feminist identities. These have become key themes in Postmodernist work.

In many ways, Postmodernism is both a rejection of Modernism and a continuation of it. In the visual arts, for instance, an eclectic, politically committed assemblage like Judy Chicago's *The Dinner Party* (1974–9) obviously refutes the modernist dogma that art has no connection with everyday reality, its only business being with formal issues of line and colour. However, modernism contained strands other than the 'formalist' one, and Postmodernism continues the experimentation and game-playing of the tradition that begins with Marcel Duchamp and develops through Dada, Surrealism, Neo-Dada, Pop and Conceptual Art.

Judy Chicago
The Dinner Party, 1974–9
Ceramic, porcelain,
textile; triangular table,
1463 x 1463 cm
(576 x 576 in.)
Brooklyn Museum,
Brooklyn

A homage to women in history, Chicago's installation was a collaborative effort involving more than a hundred women in its production. It was also hugely popular: over 100,000 people saw it when it opened at the San Francisco Museum of Modern Art in 1979.

KEY ARTISTS AND ARCHITECTS
Judy Chicago (b.1939), USA
Jenny Holzer (b.1950), USA
Barbara Kruger (b.1945), USA
Charles Moore (1925–93), USA
Richard Prince (b.1949), USA
David Salle (b.1952), USA
Julian Schnabel (b.1951), USA
Cindy Sherman (b.1954), USA
Ettore Sottsass (1917–2007), Italy

KEY FEATURES
Playful, fanciful, irreverent
Variety and diversity of materials, styles, structures and
 environments
Critical, experimental

MEDIA
All

KEY COLLECTIONS
Brooklyn Museum, Brooklyn, NY, USA
Groninger Museum, Groningen, Netherlands
Kunstmuseum Wolfsburg, Wolfsburg, Germany
Museum of Contemporary Art, Chicago, IL, USA
Museum of Modern Art, New York, NY, USA
National Museum of Women in the Arts, Washington, DC, USA
Solomon R. Guggenheim Museum, New York, NY, USA
Tate, London, UK

SOUND ART

c.1970 –

Sound Art (or Audio Art) achieved significant recognition as a category by the late 1970s, and was well known by the 1990s, when artists from all over the world were involved in works that used sound. The sounds can be natural, man-made, musical, technological or acoustic, and the works can take the form of assemblage, installation, video, performance and Kinetic Art, as well as painting and sculpture.

Lee Ranaldo, Christian Marclay and Brian Eno have produced bodies of visual art that are enriched rather than defined by their musical backgrounds. Eno has collaborated with other artists, such as Laurie Anderson and Mimmo Paladino (see Transavanguardia). Just as Anderson, Ranaldo, Marclay and Eno have fused aspects of high art and popular culture, much recent Sound Art is nurtured by club culture and the use of electronic music and sampling. Sound Art alerts the viewer to the multi-sensory experience of perception. In *Crossfire* (2007), for instance, Marclay used clips from Hollywood films of guns being fired to compose a powerful video installation and percussion piece.

Christian Marclay
Guitar Drag, 2000
Video projection, running time: 14 minutes
Paula Cooper Gallery, New York

The fourteen-minute video of an (amplified) electric guitar being pulled behind a pick-up truck along the dirt roads of Texas not only produces an extraordinary noise but also brings to mind a whole range of references, from lynchings to road movies.

KEY ARTISTS

Laurie Anderson (b.1947), USA
Tarek Atoui (b.1980), Lebanon
Brian Eno (b.1948), UK
Florian Hecker (b.1975), Germany
Christian Marclay (b.1955), USA–Switzerland
Lee Ranaldo (b.1956), USA
Samson Young (b.1979), Hong Kong

KEY FEATURE

Use of sound

MEDIA

Painting, sculpture, assemblage, installation, video and performance

KEY COLLECTIONS

Hamburger Kunsthalle, Hamburg, Germany
Museum Ludwig, Cologne, Germany
Museum of Modern Art, New York, NY, USA
Stedelijk Museum, Amsterdam, Netherlands
Tate, London, UK

TRANSAVANGUARDIA
1979–90s

In 1979 Italian art critic Achille Bonito Oliva named the Italian version of Neo-Expressionism 'Transavanguardia' ('beyond the avant-garde') and the name has been used since to refer to work produced in the 1980s and 1990s by Sandro Chia, Francesco Clemente, Enzo Cucchi and Mimmo Paladino. Their work marked a return to painting characterized by a certain violence of expression and handling, and by an air of romantic nostalgia for the past. Colourful, sensual and dramatic, the paintings show a real sense of relish in the rediscovery of the tactile and expressive aspects of the materials of painting.

The art of the Transavanguardia draws specifically on Italy's rich cultural heritage. In Chia's paintings one often senses that the whole of the history of art and culture is being brought into play. Paladino's art also traverses time and styles, but in an almost archaeological fashion. Cucchi's dark landscapes of his hometown are closest in feeling to the northern Expressionists of the early part of the century (see Expressionism). If Cucchi seems to revive the notion of the artist as visionary, the eclectic work of Clemente takes the Expressionist precept of art as a vehicle for self-expression to a new level. His images function as psychological self-portraits, often portraying the artist as an isolated, misunderstood hero.

Enzo Cucchi
A Painting of Precious Fires, 1983
Oil on canvas with neon,
297.8 x 390 cm
(117¼ x 153½ in.)
Gerald S. Elliott
Collection of
Contemporary Art,
Chicago

The Adriatic port city of Ancona in central Italy, where Cucchi's family has farmed for generations, provided him with a setting of landslides and stubble-burning which take on an apocalyptic energy in his paintings.

KEY ARTISTS
Sandro Chia (b.1946), Italy
Francesco Clemente (b.1952), Italy
Enzo Cucchi (b.1949), Italy
Mimmo Paladino (b.1948), Italy

KEY FEATURES
Colourful and dramatic
Sensual and romantic
Tactile use of paint
Expressive

MEDIA
Painting

KEY COLLECTIONS
Castello di Rivoli Museo d'Arte Contemporanea, Rivoli, Italy
Museo di Capodimonte, Naples, Italy
Solomon R. Guggenheim Museum, New York, NY, USA
Tate, London, UK

NEO-EXPRESSIONISM
c.1980 –

Neo-Expressionism ('neo' meaning new, young or revived) emerged at the end of the 1970s, partly as a result of a widespread dissatisfaction with Minimalism and Conceptual Art. The cool and cerebral approach of those movements along with their preference for purist abstraction were flouted by the Neo-Expressionists who embraced the so-called 'dead' art of painting and flaunted all that had been discredited – figuration, subjectivity, overt emotion, autobiography, memory, psychology, symbolism, sexuality, literature and narrative.

The term describes a shared international tendency rather than a specific style – as did Expressionism early in the twentieth century. Broadly speaking, Neo-Expressionist work is characterized by a number of features, both technical and thematic. The handling of materials tends to be tactile, sensuous or raw, and vibrantly expressive of emotions (both joyful and painful). Subjects of the work frequently display a deep involvement with the past, either collective history or personal memory, explored through allegory and symbolism. Neo-Expressionst work also draws on the rich history of painting, sculpture and architecture, using traditional materials and taking up themes explored by artists in the past.

Anselm Kiefer
Margarethe, 1981
Oil, acrylic, emulsion and
straw on canvas, 280 x
400 cm (110¼ x 157½ in.)
Private collection

Kiefer often uses non-art materials in his paintings (in this example, straw) to enrich his surfaces. The aesthetic arena of the canvas becomes a place where traumatic political and historical issues, particularly those of his native Germany, can be addressed.

KEY ARTISTS
Miquel Barceló (b.1957), Spain
Georg Baselitz (b.1938), Germany
Jean-Michel Basquiat (1960–88), USA
Anselm Kiefer (b.1945), Germany
Per Kirkeby (b.1938), Denmark
Gerhard Richter (b.1932), Germany
Julian Schnabel (b.1951), USA

KEY FEATURES
Expressive
Figurative, emotive and gestural
Sensual, tactile, raw use of paint
References to the past

MEDIA
Painting, sculpture and installation

KEY COLLECTIONS
Groninger Museum, Groningen, Netherlands
Louisiana Museum of Modern Art, Humlebaek, Denmark
Museum of Modern Art, New York, New York, NY, USA
San Francisco Museum of Modern Art, San Francisco, CA, USA
Solomon R. Guggenheim Museum, New York, NY, USA
Stedelijk Museum, Amsterdam, Netherlands
Tate, London, UK

NEO-POP

c.1980 –

Neo-Pop (or Post-Pop) refers to the work of a number of artists who emerged on the New York art scene during the late 1980s. Neo-Pop reacted to the dominance of Minimalism and Conceptual Art during the 1970s. Using 1960s Pop Art methods, materials and images as a starting point, Neo-Pop also reflected the heritage of Conceptual Art in its sometimes ironic and objective style. This dual inheritance is demonstrated in the media-based photographic work of self-taught artist Richard Prince, language works by Jenny Holzer, and Haim Steinbach and Jeff Koons's use of found popular imagery. Koons became notorious in the 1980s for his elevation of kitsch into high art.

Neo-Pop influenced artists of the 1990s, including Takashi Murakami, Gavin Turk and Damien Hirst. Turk's *Pop* (1993) is a waxwork figure of the artist dressed as Sid Vicious (member of the punk band the Sex Pistols) in the outfit associated with Vicious's version of Frank Sinatra's 'My Way', in the pose of Elvis Presley as a cowboy, as portrayed by Pop artist Andy Warhol, encased in a glass box. *Pop* exposes the myth of creative originality, and reflects on the rise of pop music, pop art, the pop star, and the artist as pop star.

Jeff Koons
Balloon Dog (Magenta), 1994–2000
Mirror-polished stainless steel with transparent colour coating, 307 x 363 x 114cm (121 x 143 x 45 in.)
François Pinault collection, Paris

Koons's shiny magenta steel sculpture measures over 3 metres (10 feet) in height. Its sheer scale and detail of construction stands in absurd contrast to its subject, yet lends it an awesome presence. Recalling Claes Oldenburg's ironic monumentalizing of everyday objects (see Pop Art and Site Works), Koons transforms the ephemeral child's toy into a massive, durable monument.

KEY ARTISTS

Damien Hirst (b.1965), UK
Jenny Holzer (b.1950), USA
Jeff Koons (b.1955), USA
Takashi Murakami (b.1962), Japan
Richard Prince (b.1949), USA
Haim Steinbach (b.1944), USA
Gavin Turk (b.1967), UK

KEY FEATURES

Imagery from popular culture, advertising, toys, readymades

MEDIA

Painting, photography, assemblage, sculpture and installation

KEY COLLECTIONS

The Broad, Los Angeles, CA, USA
Modern Art Museum of Fort Worth, Fort Worth, TX, USA
Museum of Contemporary Art, Chicago, IL, USA
Newport Street Gallery, London, UK
Tate, London, UK

ART AND NATURE
1990s –

In Art and Nature projects artists collaborate with nature, working with its materials and within natural environments. Some works are ephemeral and only exist as photographs; others are temporary and performative; while others are more durable, (semi) permanent outdoor installations. Engaging with the work is a multi-sensory and multi-dimensional experience involving the play of light and shadow, the feel of the space, its sounds and scents, and the passage of time.

A number of noteworthy international art and nature projects came into being at the end of the twentieth century to foster this type of art, including the Grizedale Sculpture Project in the Lake District in England, Arte Sella in northern Italy, Tranekær International Centre for Art and Nature (TICKON) in southern Denmark and the Nature-based Sculpture Program at the South Carolina Botanical Garden in the USA. The mission of these projects is to encourage artists to make artworks in nature and from nature, utilizing the natural environment as both site for their works and source of inspiration and materials. The artworks are then left to interact with their environment, wildlife and visitors, evolving and decaying over time.

Alfio Bonanno
Refuge for lizards, 2017
Site-specific installation
made from old grape
vines, 2.5 x 5.9 x 7.8 m
(8¼ x 19⅓ x 25½ ft)
Radicepura, Giarre,
Catania, Sicily

**Bonanno is a pioneering
environmental artist and
political and ecological
activist who has been
making site-specific
installations, temporary
and permanent, since the
1970s. His interventions
in nature make you
more acutely alive to
your surroundings and
heighten your awareness
of certain aspects of
nature – its beauty, its
brutality, its transience
and its permanence.**

Alfio Bonanno
Detail from *Refuge for lizards*, 2017

This detail shows a lizard in Bonanno's collaboration with nature in Sicily. The installation is made of very old grape vines from the Radicepura Botanical Garden.

KEY ARTISTS

Alfio Bonanno (b.1947), Italy–Denmark
Agnes Denes (b.1938), USA
Patrick Dougherty (b.1945), USA
Chris Drury (b.1948), UK
Andy Goldsworthy (b.1956), UK
Mikael Hansen (b.1943), Denmark
Giuliano Mauri (1938–2009), Italy
David Nash (b.1945), UK
Nils-Udo (b.1937), Germany

KEY FEATURES

Art made in nature and from nature

MEDIA

Sculpture, assemblage, installation, environments and
photography

KEY LOCATIONS

Arte Sella, Borgo Valsugana, Trento, Italy
Grizedale Sculpture, Grizedale Forest, Ambleside, Cumbria, UK
Sculpture in the Parklands, Lough Boora, Co. Offaly, Ireland
South Carolina Botanical Garden, Clemson, SC, USA
Strata Project, Pinsiö, Finland
Tranekær International Centre for Art and Nature (TICKON),
Langeland, Denmark
Virginia B. Fairbanks Art & Nature Park: 100 Acres, Indianapolis,
IN, USA

ART PHOTOGRAPHY
1990s –

Art Photography was firmly embedded as a valid art form by the close of the twentieth century. Of the multiple sensibilities that inform the making of Art Photography, storytelling, looking at everyday objects and domestic scenes, and the use of a deadpan aesthetic have been particularly prominent strands.

Theatrical photography involves performances or events especially devised for the camera. Cindy Sherman, with her body of work exploring issues of female identity, is the best known and most influential artist working in this strand.

So-called 'tableau' photography sets up single-image narratives evoking the storytelling tradition of eighteenth- and nineteenth-century history painting. Jeff Wall is the star of this genre, with his elaborately staged, dramatic scenes ostensibly of everyday life. Other artists, such as Wolfgang Tillmans, use everyday objects and the fabric of daily life as their subject matter, casting light on the overlooked and encouraging us to see the world around us in subtly different ways. The 'deadpan' aesthetic is characterized by images made with medium or large-format cameras. Andreas Gursky's imposing photographs (they can measure up to 2 metres high and 5 metres wide) of precise scenes of contemporary urban life from extreme vantage points made him the master of this type of pictorial photography during the 1990s.

Art Photography is a fluid, flexible form that is constantly evolving and becoming ever more central to contemporary art practice.

Jeff Wall
A Sudden Gust of Wind (after Hokusai), 1993
Transparency in lightbox, 229 x 377 cm (90¼ x 148½ in.)
Private collection

Wall's scenes are often displayed in lightboxes, heightening their spectacular presence. Many of his images specifically evoke works by historical artists, in this case, *Travellers Caught in a Sudden Breeze at Ejiri* (c.1832), a woodcut by Japanese artist Katsushika Hokusai (1760–1849). This digital montage took Wall over a year to create from more than 100 photographs, which were staged, taken, scanned, digitally processed and then elements were collaged together into a single image.

KEY ARTISTS
Richard Billingham (b.1970), UK
Jean-Marc Bustamante (b.1952), France
Nan Goldin (b.1953), USA
Andreas Gursky (b.1955), Germany
Vik Muniz (b.1961), Brazil
Cindy Sherman (b.1954), USA
Hiroshi Sugimoto (b.1948), Japan
Wolfgang Tillmans (b.1968), Germany
Jeff Wall (b.1946), Canada

KEY FEATURES
Storytelling, theatrical, deadpan, intimate, montages,
 use of digital technologies

MEDIA
Photography and installation

KEY COLLECTIONS
Centre Georges Pompidou, Paris, France
Los Angeles County Museum of Art, Los Angeles, CA, USA
Museum of Modern Art, New York, NY, USA
Tate, London, UK
Vancouver Art Gallery, Vancouver, BC, Canada
Victoria and Albert Museum, London, UK

DESTINATION ART
c.2002–

Destination Art is art that you must find and meet in its own space and on its own terms. The label acknowledges and explores the often reciprocal dynamic that the art and its setting exert on each other. Thus, it is the art in its particular setting that is the destination. Some Destination Art requires a committed pilgrimage to find and see it – in deserts, forests and quarries, on farmland and mountains, in ghost towns and nature reserves – while other works may be hidden gems in urban environments. Antony Gormley's *Inside Australia* (2002), for example, an installation of fifty-one black stainless steel figures on a dry salt bed, is in a remote part of Western Australia, while Jean Dubuffet's sculpture-tower, *Tour aux Figures* (1988), can be found in the outskirts of Paris.

Antony Gormley
Inside Australia, 2002–3
Cast alloy of iron,
molybdenum, iridium,
vanadium and titanium
Lake Ballard,
Western Australia

Gormley's installation
of fifty-one black
stainless steel figures
on the dry salt bed of
Lake Ballard, near the
tiny outback town of
Menzies (population:
130), is located some
800 km (500 miles)
northeast of Perth in a
remote part of Western
Australia. The work is
made of the sculptures
and the landscape, and
the figures are based
on the local residents.
Gormley sees the work
as 'an excuse for coming
here and thinking about
this place and the people
who dwell in it'.

Destination Art often brings contemporary art to the remote regions of a nation. Alfio Bonanno's *Målselv Varde* (2005), a site-specific landscaped environment for a small rural community in Arctic Norway, is but one of these projects. Ivan Klapez's massive granite sculptures (from 2002) for a new village near Morogoro in Tanzania is another, while Andy Goldsworthy's *Refuges d'art* (1995–2013) is a series of stone shelters spread over 160 km (100 miles) of countryside in Alpes de Haute-Provence, France. The journey to these artworks is part of the experience and the sense of adventure all adds to the thrill of discovery.

KEY ARTISTS

Alfio Bonanno (b.1947), Italy–Denmark
Ian Hamilton Finlay (1925–2006), UK
Andy Goldsworthy (b.1956), UK
Antony Gormley (b.1950), UK
Donald Judd (1928–94), USA
Niki de Saint Phalle (1930–2002), France–USA
Jean Tinguely (1925–91), Switzerland
James Turrell (b.1943), USA

KEY FEATURES

Location is an integral ingredient, as is the journey
 to find the artwork
The artwork often turns the site into a destination

MEDIA

Sculpture, earthworks, installation and environments

KEY SITES

Alfio Bonanno, *Målselv Varde*, Olsborg, Troms, Norway
Niki de Saint Phalle, *Giardino dei Tarocchi*, Pescia Fiorentina,
 Italy
Andy Goldsworthy, *Refuges d'art*, Digne-les-Bains, France
Antony Gormley, *Inside Australia*, Lake Ballard, Australia
Ian Hamilton Finlay, *Little Sparta*, Dunsyre, Lanarkshire,
 Scotland, UK
Donald Judd and others, *Chinati Foundation*, Marfa, TX, USA
Ivan Klapez, *Stepinac and Nyerere*, Dakawa, Tanzania
Albert Szukalski and others, *Goldwell Open Air Museum*, near
 the ghost town of Rhyolite, Nevada, USA
Jean Tinguely and friends, *Le Cyclop*, Milly-la-Forêt, France

GLOSSARY

Abstraction: art that does not try to represent objects as they appear in the world. Also called non-objective art.

Academic painting: the official styles of painting taught in art academies and supported by the establishment. Generally seen as conservative and determined to preserve the status quo in contrast to the experimental art of the avant-garde.

Action Painting: term applied to the work of some Abstract Expressionists, especially Jackson Pollock and Willem de Kooning, whose 'gestural' canvases were supposed to express an Existential element of the artist's personality achieved through the apparently impulsive application of materials.

Adhocism: term used to describe the Postmodernist practice in architecture and design of using and combining pre-existing styles and forms to create a new entity.

Airbrush: a small air-operated tool used to spray a fine mist of paint.

Appropriation: art that adopts (or 'quotes') motifs, ideas or images from past work in new contexts as a method of questioning representation itself. A popular Postmodernist practice.

Applied art: functional objects designed and decorated to make them artistic as well as functional, made in a variety of materials including glass, ceramics, textiles, furniture, printing, metalwork and wallpaper.

Assemblage: term used by American curator William C. Seitz for his seminal exhibition at the Museum of Modern Art in New York in 1961. The 'Art of Assemblage' was an international survey of art which shared certain physical characteristics, namely: '1. They are predominantly assembled rather than painted, drawn, modelled, or carved. 2. Entirely or in part, their constituent elements are preformed natural or manufactured materials, objects, or fragments not intended as art materials.' Collage taken into three dimensions.

Automatism: a spontaneous method of writing or painting when the writer or artist is not consciously thinking about what they are doing.

Avant-garde: from the French for vanguard, meaning ahead of one's contemporaries – experimental, innovative and revolutionary.

Classical: term used to describe the realistic, lifelike, rational art and architecture of ancient Greece and Rome.

Collage: from French verb *coller*, meaning to stick on. A technique in which mixtures of different pre-existing materials are stuck onto a flat surface to create a work of art. Pioneered by the Cubists.

Combine: term coined by Robert Rauschenberg in 1954 to refer to his new works that had aspects of both painting and sculpture. Those intended to be mounted on a wall were termed 'Combine' paintings, and freestanding works, 'Combines'.

Deconstruction: a popular Postmodernist practice in which motifs or images from past work are stripped of their conventional meanings as a method of questioning the very nature of representation.

Divisionism: term coined by Neo-Impressionist Paul Signac to describe the theory of applying individual patches or dots of colour to be mixed optically by the viewer (see also Pointillism, page 171).

Documentation: texts, photographs, films and publications that record the creation of an artwork.

Formalism: theory of modernism, particularly championed by the influential American art critic Clement Greenberg in the 1960s. He believed that each art form should restrict itself to those qualities essential only to itself; therefore painting, a visual art, should restrict itself to visual or optical experiences, and avoid any associations with sculpture, architecture, theatre, music or literature. Works that stressed their formal qualities, exploiting the purely optical qualities of pigment, emphasizing the shape of the canvas and the flatness of the picture plane, represented for him the superior art of the 1960s (see Post-Painterly Abstraction, pages 128–9).

Found object: non-art objects incorporated into artworks.

Happenings: 'Something to take place; a happening' (Allan Kaprow, 1959). The term inspired work by a variety of Conceptual and Performance artists including Kaprow, members of Fluxus, Claes Oldenburg and Jim Dine, who combined elements of theatre and gestural painting.

Hard-edge painting: term coined in 1959 as an alternative to 'gestural abstraction', used to describe abstract works comprised of separate large flat forms (Ellsworth Kelly, Kenneth Noland and Ad Reinhardt; see Post-Painterly Abstraction, pages 128–9).

Installation: Installation art shares its origins in the early 1960s with Assemblages and Happenings. At the time the word 'environment' was used to describe such works as the tableaux of Funk artist Ed Kienholz, inhabitable Assemblages by Pop artists and Happenings. These mixed-media constructions engaged with their surrounding space and incorporated viewers into the work. Expansive and encompassing, they were intended as catalysts for new ideas, not receptacles of fixed meanings. Installations can be site-specific or intended for different locations.

Japonisme: term used to indicate the recurring influence of Japanese art on western (particularly European) art groups, such as the Post-Impressionists, Art Nouveau artists and Expressionists.

Junk Art: art made from salvaged rubbish.

Lyrical Abstraction (French: *Abstraction Lyrique*): term introduced after 1945 by French painter Georges Mathieu to describe a mode of painting that resisted all formalized approaches, to convey spontaneous expressions of cosmic purity. Wols and Hans Hartung were among those associated with the term (see Art Informel, pages 102–3).

Manifesto: a published declaration of intention, mission and vision. A standard feature of many early twentieth-century art movements, such as Futurism.

Modernism: emerging in the late nineteenth century, it was a belief that art should reflect modern times. Successive groups of artists experimented with alternative ways to make art, breaking with the classical traditions taught since the Renaissance. In the visual arts, it revolutionized ways of conceiving and perceiving the artistic object.

Papier collé: French for pasted paper. Compositions of cut-out pasted paper. A type of collage pioneered by the Cubists.

Pointillism: technique used by Neo-Impressionists Paul Signac and Georges Seurat. Drawing on the premise that colour is mixed in the eye instead of on the palette, they perfected a technique for applying tiny dots of pure, unmixed colour on the canvas in such a way that, to a spectator standing at an appropriate distance, they appeared to react together.

Readymade: name used by Marcel Duchamp for certain kinds of found objects used or exhibited by artists with little or no modification by the artist.

Salon: annual exhibition organized by the French Royal Academy of Painting and Sculpture in Paris from the seventeenth century. Classical subjects and traditional styles were usually favoured by its judges for inclusion.

Site-specific: term that began to be used during the 1960s to describe work by Minimalist, Earth and Conceptual artists that specifically engages with its context (see Site Works, pages 148–9).

INDEX OF ARTISTS

PICTURE ACKNOWLEDGEMENTS

2 The State Russian Museum, St Petersburg; **8**, **18** Helen Birch Bartlett Memorial Collection, 1926.224. The Art Institute of Chicaco/ Art Resource, NY/Scala, Florence; **10** Musée Marmottan Monet, Paris. Photo Studio Lourmel; **11** Musée d'Orsay, Paris; **12** Metropolitan Museum of Art, New York. Gift of Mr and Mrs Nate B. Spingold, 1956.56.231; **13** National Gallery of Art, Washington, DC. Collection of Mr and Mrs Paul Mellon, 1983.1.18; **14** Private collection; **16** National Gallery, Oslo; **20** National Galleries of Scotland, Edinburgh; **22** Cleveland Museum of Art, Bequest of Leonard C. Hanna, Jr., 1958.32; **23** Philadelphia Museum of Art, Pennsylvania. George W. Elkins Collection, 1936; **24** Österreichische Galerie Belvedere, Vienna; **26** Stedelijk Museum, Amsterdam; **28** National Gallery of Art, Washington, DC. Chester Dale Collection, 1944.13.1; **29** Museum of Fine Arts, Boston. The Hayden Collection, Charles Henry Hayden Fund, 45.9; **30** San Francisco Museum of Modern Art, San Francisco. © Succession H. Matisse/DACS 2017; **32** Museum Ludwig, Cologne. ML 76/2716; **33** Walker Art Center, Minneapolis. Gift of the T.B. Walker Foundation, Gilbert M. Walker Fund, 1942; **34** National Gallery of Art, Washington, DC. Ailsa Mellon Bruce Fund, 1978.48.1; **35** Leopold Museum, Vienna, Inv. 1398; **36** Kunstmuseum Bern, Bern. © ADAGP, Paris and DACS, London 2018; **37** Musée Picasso, Paris. © Succession Picasso/DACS, London 2018; **39** Yale University Art Gallery, New Haven. Gift of Collection Société Anonyme; **40** Civica Galleria d'Arte Moderna, Milan. © DACS 2018; **41** Private collection; **42** The Albright-Knox Art Gallery, Buffalo. Gift of Seymour H. Knox. Courtesy Jean-Pierre Joyce/Morgan Russell Estate; **44** Private collection; **46** Private collection. © ADAGP, Paris and DACS, London 2018; **48** The State Tretyakov Gallery, Moscow; **49** The State Russian Museum, St Petersburg; **50** Private collection; **51** National Museum, Stockholm; **52** Moderna Museet, Stockholm. Photo Per-Anders Allsten © DACS 2018; **54** National Gallery of Art, Washington, DC. Gift from the Collection of Raymond and Patsy Nasher, 2009.72.1; **56** © Succession Marcel Duchamp/ADAGP, Paris and DACS, London 2018; **58** Stedelijk Museum, Amsterdam; **60** Musée National d'Art Moderne, Centre Georges Pompidou, Paris. Photo CNAC/MNAM Dist. RMN/© Jacqueline Hyde. © FLC/ ADAGP, Paris and DACS, London 2018; **62** Art Institute of Chicago, Friends of American Art Collection; **64** The Samuel Courtauld Trust, the Courtauld Gallery, London; **66** Bauhaus-Archiv, Museum für Gestaltung, Berlin. © DACS 2018; **68** Metropolitan Museum of Art, New York; Alfred Stieglitz Collection; **71** Private collection. © ADAGP, Paris and DACS, London 2018; **72** Schomburg Center for Research in Black Culture, Art and Artifacts Division, New York Public Library. © Heirs of Aaron Douglas/VAGA, NY/DACS, London 2017; **74** National Palace, Mexico City, Mexico. © Banco de México Diego Rivera Frida Kahlo Museums Trust, Mexico, D.F. / DACS 2018; **76** Los Angeles County Museum of Art (LACMA). Purchased with funds provided by the Mr and Mrs William Preston Harrison Collection, 78.7. © ADAGP, Paris and DACS, London 2018; **78** Imperial War Museum, London; **80** Lindenau-Museum, Altenburg. © DACS 2018; **82** National Gallery of Art, Washington, DC. Gift of the Collection Committee, 1981. © Successió Miró/ADAGP, Paris and DACS London 2018; **83** Private collection. © Salvador Dalí, Fundació Gala-Salvador Dalí, DACS 2017; **84** Stedelijk Museum, Amsterdam. © Man Ray Trust/ADAGP, Paris and DACS, London 2018; **86-7** Kunsthaus Zurich. © DACS 2018; **88** Art Institute of Chicago, Friends of American Art Collection; **90** Library of Congress, Washington, DC © Estate of Ben Shahn/DACS, London/VAGA, New York 2017; **92** Private collection. Photo Fine Art Images/Heritage Images/Getty Images; **94** Courtesy Yayoi Kusama Inc., Ota Fine Arts, Tokyo/Singapore and Victoria Miro, London. © Yayoi Kusama; **96** The Hepworth Wakefield, West Yorkshire. Reproduced by permission of The Henry Moore Foundation; **98** Private collection. © ADAGP, Paris and DACS, London 2018; **100** Adolf Wölfli Foundation, Fine Arts Museum, Bern; **102** Museum Ludwig, Cologne. © ADAGP, Paris and DACS, London 2018; **104** Private collection. © 1998 Kate Rothko Prizel & Christopher Rothko ARS, NY and DACS, London; **105** Metropolitan Museum of Art, George A. Hearn Fund, 1957. © The Pollock-Krasner Foundation ARS, NY and DACS, London 2018; **107** Private collection, Boston. © The Willem de Kooning Foundation/Artists Rights Society (ARS), New York and DACS, London 2018; **108** Tate, London. © Karel Appel Foundation/DACS 2018; **111** © The Jess Collins Trust and used by permission; **112** Moderna Museet, Stockholm. © Robert Rauschenberg Foundation/DACS, London/VAGA, New York 2018; **114** President and Fellows, Harvard College, Harvard Art Museums/Busch-Reisinger Museum, Gift of Sibyl Moholy-Nagy; **116** Private collection. © Estate of Roy Lichtenstein/DACS 2018; **117** Kunsthalle Tübingen, © R. Hamilton. All Rights Reserved, DACS 2018; **119** National Gallery of Art, Washington, DC, Reba and Dave Williams collection, Gift of Reba and Dave Williams 2008.115.4946, © 2018 The Andy Warhol Foundation for the Visual Arts, Inc./Artists Rights Society (ARS), New York and DACS, London; **120** Courtesy Yayoi Kusama Inc., Ota Fine Arts, Tokyo/Singapore and Victoria Miro, London. © Yayoi Kusama; **122** Museum of Modern Art, New York. Hillman Periodical Fund. Courtesy Michael Kohn Gallery, Los Angeles. Photo George Hixson. © Estate of Bruce Conner. ARS, NY/ DACS, London 2018; **125** Museum of Modern Art, New York, The Gilbert and Lila Silverman Fluxus Collection Gift, 2008. Photo R. H. Hensleig; © The Estate of Yves Klein, c/o DACS, London 2018; **126** Museum of Modern Art, New York. The Gilbert and Lila Silverman Fluxus Collection Gift, 2008. Photo R. H. Hensleigh. © DACS 2018; **129** The Lannan Foundation, New York. © Frank Stella. ARS, NY and DACS, London 2017; **130** © Bridget Riley 2017. All rights reserved; **132** Courtesy the artist; **134** Hirshhorn Museum and Sculpture Garden, Washington, DC. © Judd Foundation/ARS, NY and DACS, London 2018; **136** Collection of the Flemish community, the SMAK – the Museum of Ghent © The Estate of Marcel Broodthaers/DACS 2018; **138** © Bruce Nauman/Artists Rights Society (ARS), New York and DACS, London 2018; **140** Photo Ellen Page Wilson. © Chuck Close, courtesy Pace Gallery; **142** Courtesy Paik estate; **144** Courtesy the artist; **146** Dia Art Foundation, New York; **148** The Savings Bank Foundation DNB. Photo Lars Svenkerud. Courtesy the artist; **151** New Orleans, Louisiana. Photograph Moore/Anderson Architects, Austin, Texas; **152** Brooklyn Museum, Brooklyn, New York. © Judy Chicago. ARS, NY and DACS, London 2018; **154** Courtesy Paula Cooper Gallery, New York. © Christian Marclay; **157** The Gerald S. Elliott Collection of Contemporary Art, Chicago. © Galerie Bruno Bischofberger, Mäennedorf-Zürich; **158** Private collection. © Anselm Kiefer; **160** © Jeff Koons; **162**, **163**, **165** Courtesy the artists; **166** Geneviève Vallée/Alamy Stock Photo

-

To Justin, Charlie and Cathy

-

Modern Art © 2018 Thames & Hudson Ltd, London

Text © 2018 Amy Dempsey

Design by April

First published in 2018 in the United States by Thames & Hudson Inc., 500 Fifth Avenue, New York, New York 10110

www.thamesandhudsonusa.com

Library of Congress Control Number 2017945426
ISBN 978-0-500-29322-5

Printed and bound in China by Toppan Leefung Printing Ltd

Front cover: Charles Demuth, *I Saw the Figure 5 in Gold*, 1928 (detail from page 68). Metropolitan Museum of Art, New York, Alfred Stieglitz collection

Title page: Kazimir Malevich, *Suprematism*, 1915 (detail from page 49). The State Russian Museum, St Petersburg

Chapter openers: page 8 Georges Seurat, *A Sunday on La Grande Jatte – 1884*, 1884–6 (detail from page 18). Art Institute of Chicago, Chicago; **page 26** Piet Mondrian, *Composition in Red, Black, Blue, Yellow and Grey*, 1920 (detail from page 58). Stedelijk Museum, Amsterdam; **page 62** Grant Wood, *American Gothic*, 1930 (detail from page 88). Art Institute of Chicago; **page 94** Yayoi Kusama, *'Anti-War' Naked Happening and Flag Burning at Brooklyn Bridge*, 1968 (see also page 120); **page 132** Jeff Wall, *A Sudden Gust of Wind (after Hokusai)*, 1993 (detail from page 165). Private collection

Quotations: page 9 August Endell, 'Formenschönheit und Decorative Kunst' (The Beauty of Form and Decorative Art) in *Dekorative Kunst 1* (Munich, 1898); **page 27** Henri Matisse, 'Notes of a Painter' in *La Grande Revue* (Paris, 25 December 1908); **page 63** Amédée Ozenfant and Le Corbusier, *Après Le Cubisme* (After Cubism) (1918); **page 95** Albert Camus, *Combat* (1944) (*Combat* was a French newspaper founded during World War II to support the Resistance. Camus was its editor-in-chief 1943–7); **page 133** Mimmo Paladino, *Städtische Galerie im Lenbachhaus* (Munich, 1985), pages 43–4